A Doubtful River

A Doubtful

Environmental Arts and Humanities Series

UNIVERSITY OF NEVADA PRESS ▲▲ RENO • LAS VEGAS

River

Robert Dawson Peter Goin Mary Webb

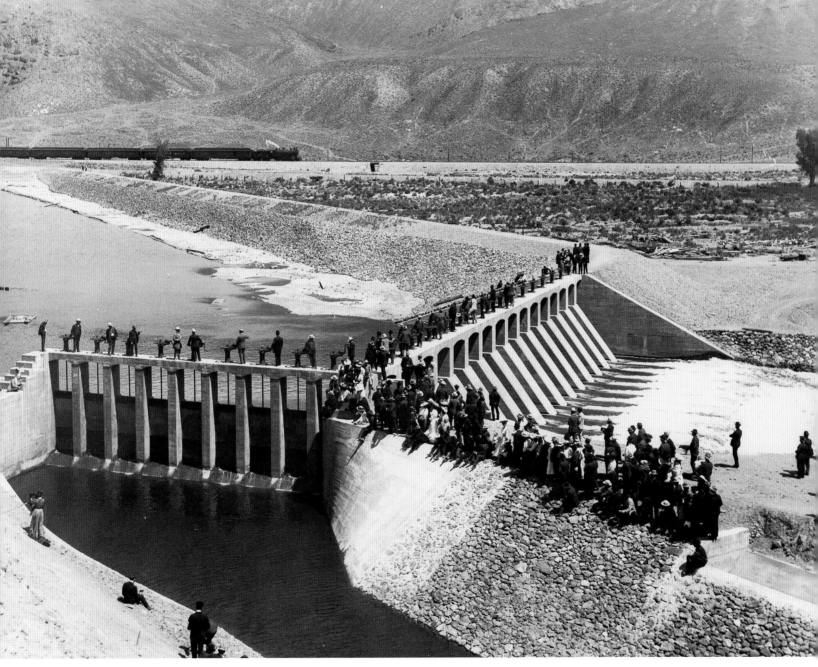

Winner of the Wilbur S. Shepperson Humanities Book Award for 2000

This book is the recipient of the Wilbur S. Shepperson Humanities Book Award, which is given annually in his memory by the Nevada Humanities Committee and the University of Nevada Press. One of Nevada's most distinguished historians, Wilbur S. Shepperson was a founding board member and long-time supporter of both organizations.

Environmental Arts and Humanities Series
Series Editor: Scott Slovic

This book is a collaborative project shared equally among the authors. The listing of authors is alphabetical.

University of Nevada Press, Reno, Nevada 89557 USA
Manufactured in China
Designer: Richard Hendel

This publication is made possible in part through generous grants from the Nevada Humanities Committee, a state program of the National Endowment for the Humanities and from the City of Reno C.I.T.Y. 2000 Reno Arts Commission.

Library of Congress Cataloging-in-Publication Data
Dawson, Robert, 1950–
A doubtful river / Robert Dawson, Peter Goin, Mary Webb.
 p. cm. — (Environmental arts and humanities series)
Includes bibliographical references.
ISBN 0-87417-349-3 (cloth : alk. paper)
1. Water use—Truckee River Watershed (Calif. and Nev.)
2. Truckee River Watershed (Calif. and Nev.) I. Goin, Peter, 1951– .
II. Webb, Mary Margaret, 1956– . III. Title. IV. Series.
GB1227.T78D39 2000
333.91'62'0979355—dc21 99-42383 CIP

The paper used in this book meets the requirements of American National Standard for Information Sciences—Permanence of Paper for Printed Library Materials, ANSI Z39.48-1984. Binding materials were selected for strength and durability.

Title page: Photo 1 (Christening of the Derby Dam, 1905); photographic detail on p. vi is from Photo 54 (Intake of Truckee River Canal); detail on p. viii is from Photo 55 (Wasteway Gates on Truckee Canal).

First Printing
09 08 07 06 05 04 03 02 01 00 5 4 3 2 1

This book is dedicated to

DANA & KARI GOIN

who lost their mother during

the work on this project.

Contents

Illustrations

A Doubtful River

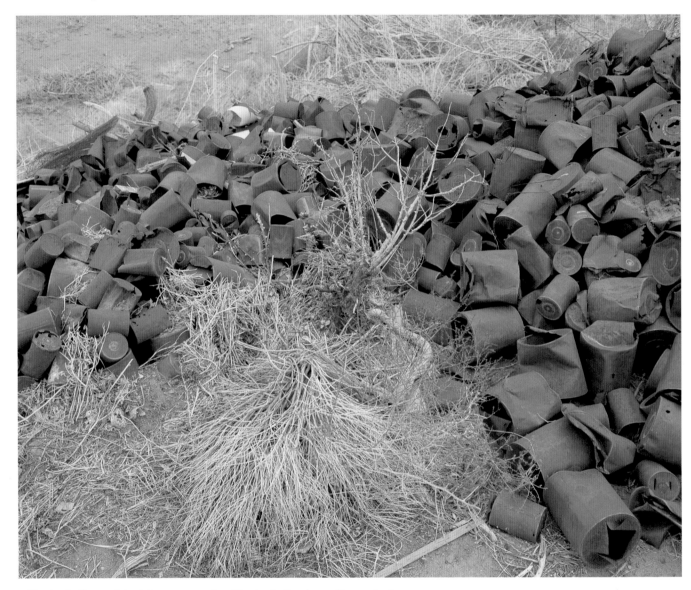

2. Trash pile from original dam construction, Newlands Canal near Hazen. [pg]

Authors' Introduction

Nevada The Leave-It State

You got money you want to gamble?

Leave it here. You got a wife you

want to get rid of? Get rid of her here.

Extra atom bomb you don't need?

Blow it up here. Nobody is gonna

mind in the slightest. The slogan of

Nevada is, "Anything goes, but don't

complain if it went."

—*The Misfits* (1961)

Water in the American West is sprayed from ornamental fountains, recycled through human-made waterfalls, and generated as ocean waves in landlocked wild-water oases. A charitable visitor might believe water is plentiful. Yet aridity is inescapable, at least in the Great Basin, which includes portions of Idaho, Nevada, Oregon, and Utah. Faced with the vastness of brown mountain ranges and a horizon tainted with industrial pollution, we can no longer sustain the illusion of plentiful water. The urban and agricultural areas located in this Great Basin region of western Nevada depend primarily upon an unpredictable snowpack in the surrounding mountain ranges and on rivers that flood or, at times, run dry (see pl. 37). While the population of the western states grows at phenomenal rates, the ancient and irreplaceable waters in the aquifers are depleted to serve the ever-increasing thirst of new development. Like many other western rivers, the Truckee, a modest, shallow stream on the eastern slope of the Sierra Nevada, has been oversubscribed for decades. This river, the life support for more than 200,000 people living in western Nevada, is threatened by an annual increase in urban population that measures consistently at nearly 6 percent.

Geographic Background

The Truckee River was the first western river to be altered by the U.S. government for irrigation purposes. The Truckee River is dammed, diverted, and divided to quench the thirst of its many users: recreationalists and power generators in Nevada and California, the Pyramid Lake Paiute Tribe, residents and businesses in the Truckee Meadows, farmers in western Nevada, and state and federal fish and wildlife agencies. Derby Dam, which diverts the Truckee east of Reno to provide water for the farms of the Lahontan Valley, was built in 1905. This visually modest dam is steeped in symbolism, since its origins can be found in the Jeffersonian ideal of an agrarian democracy. The federally funded Newlands Project, as this irrigation scheme is known, inaugurated a century of dissension and turmoil despite its publicly stated noble intentions. As the Jeffersonian premise of 160 acres—to provide food, shelter, and prosperity—encountered Nevada's alkali landscape,

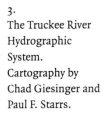

3.
The Truckee River
Hydrographic
System.
Cartography by
Chad Giesinger and
Paul F. Starrs.

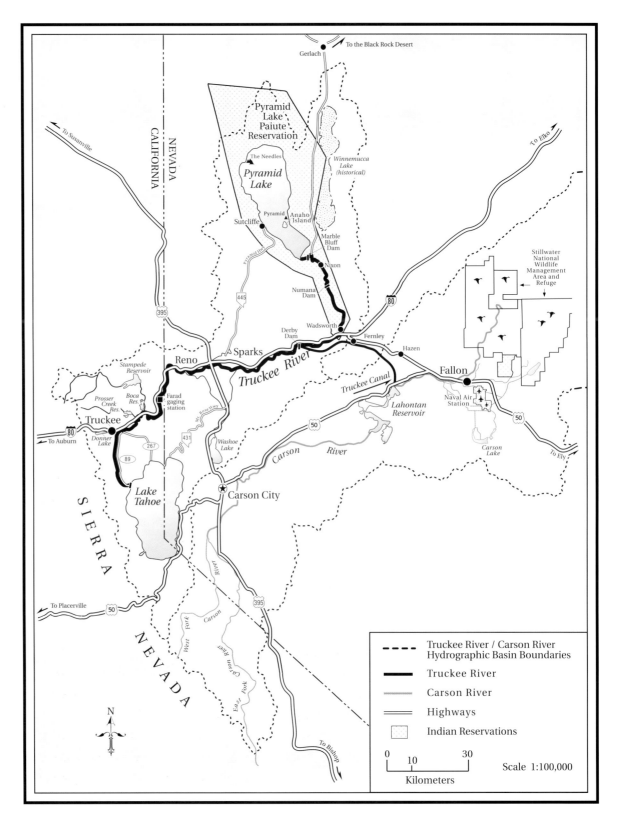

To the Black Rock Desert

Gerlach

To Susanville

NEVADA
CALIFORNIA

To Elko

Pyramid
Lake
Paiute
Reservation

The Needles

*Pyramid
Lake*

*Winnemucca
Lake
(historical)*

Sutcliffe

Pyramid

Anaho
Island

Marble
Bluff
Dam

Nixon

Numana
Dam

445

Stillwater
National
Wildlife
Management
Area and
Refuge

Derby Dam

Wadsworth

Reno

Sparks

Fernley

Hazen

395

Stampede
Reservoir

Truckee River

Truckee Canal

Fallon

80

50

Prosser
Creek
Res.

Boca
Res.

Farad
gaging
station

Mt. Rose Hwy.

*Lahontan
Reservoir*

Naval Air
Station

50

Truckee

431

*Washoe
Lake*

267

Carson

River

*Carson
Lake*

To Ely

To Auburn

*Donner
Lake*

89

To Placerville

50

S
I
E
R
R
A

*Lake
Tahoe*

Carson City

West Fork Carson River

River

East Fork Carson River

395

To Bishop

N
E
V
A
D
A

N

Truckee River / Carson River
Hydrographic Basin Boundaries

Truckee River

Carson River

Highways

Indian Reservations

0 10 30

Kilometers

Scale 1:100,000

the harsh reality of desert farming emerged. Selenium salts and arsenic drain from irrigated lands into the Stillwater National Wildlife Refuge, threatening this major birdlife habitat on the Pacific flyway. Poor soil characteristics limit crop choices, regardless of water volume. Dry years reduce agreed-upon allocations, regardless of need or legal standing.

Since the first diversion in 1906, Pyramid Lake, where the Truckee River ends, has lost more than forty-five feet of vertical shoreline, threatening vital rookeries and wildlife habitats. The Pyramid Lake Paiute Tribe, its members historically hunter-gatherers, fishers, and protectors of Pyramid Lake—which is the center of both its material culture and its spiritual cosmos—has been entangled for nearly a century seeking redress for the lost water. Lying to the east of Pyramid Lake is Winnemucca Lake; this sister lake, almost as long as Pyramid Lake but only half as wide, used to fill with Pyramid Lake's seasonal overflow and was a key staging area for migratory waterfowl. Once eighty-seven feet deep, Winnemucca Lake dried up after the waters of the Truckee were diverted at Derby Dam. Winnemucca Lake was made a national wildlife refuge in 1936, some thirty years after the start of water diversions, but refuge status was abandoned in 1962 when officials realized that the lake would never refill. In the 1950s and 1960s and for brief intervals in the 1980s and 1990s, Winnemucca Lake intermittently held water, but it is now a dry alkali lake bed.

The Stillwater National Wildlife Refuge and Management Area lies at the terminus point of diverted waters from the Truckee. Situated to the north and east of Fallon, this major wetland site endured low water because of prolonged drought and reduced Truckee River diversions. Stillwater also suffered higher levels of toxic contamination from selenium and boron dissolved in farm water draining through the ancient lake bed sediments (see pls. 139, 149). In recent wet winters (1994–1998), Stillwater has enjoyed a reprieve, but wetland acreage at times totals less than 5 percent of pre-European settlement averages. The survival of this crucial natural resource depends on negotiated settlements between radically different communities.

Purpose and Design of *A Doubtful River*

The landscape of northern Nevada is divided yet woven together by the waters of the Truckee. Connecting a tourist recreation and gaming economy, a rural ranching oasis, and an aboriginal belief system, the Truckee River offers evidence of the layered complexity inherent in creating a sense of community defined by shared needs. We hope that this book can contribute to an understanding of the debate over this watershed's environmental and political future. We invite the reader to consider how the culture of this arid land conceives of water as a commodity, an abstract legal right rather than the most basic physical source of life.

The photographs and essays bear witness to what we encountered along the length of the Truckee as we met the extraordinary range of people, environments, and landscapes that are so dependent upon its waters. The reader should understand an important design feature of *A Doubtful River*: the essays and photographs are organized geographically, following the flow of the Truckee River from its Lake Tahoe origin in the Sierra to its points of termination in the Great Basin desert. Yet this simple organizational plan presents a significant dilemma: where does the Truckee River—and therefore our story—*really* end? The diversion at Derby Dam splits the Truckee so that its waters drain in two directions, one toward Pyramid Lake, the other to Fallon to mingle with waters of a second river, the Carson, irrigating local farms and eventually recharging the wetlands at Stillwater. The photographs end at Stillwater, while the written narrative ends at Pyramid Lake. This design highlights the remarkable counterpoint of our human manipulation of arid landscapes. As you read the photographs and essays, you will directly experience the ways in which human intervention has now inextricably tied together these two landscapes and the lifestyles they represent. We cannot consider the fate of Pyramid Lake without also turning our attention to the other communities that lie in another part of this now-linked system. Finally, a concluding essay returns the reader to urban Reno to reflect on what "a doubtful river" can teach us.

About the Essays

The essays tell stories about the people who depend on and adjudicate the waters of the Truckee River. They examine the many contradictory attitudes toward the desert landscape, while focusing on those people who have made their lives here. The photographs and essays together provide a tapestry of four viewpoints woven from the two photographic perspectives, the historical images, and the essays.

The essays attempt to probe our resistance and adaptation to desert landscapes and to give voice to those people who depend on the Truckee River. This explicit purpose necessitates crossing the boundaries between fiction and nonfiction; some of the people you will encounter in the essays are based on actual people but are rendered as composites to express the variety of perspectives on the Truckee River system. The essays developed through many hours of interviews with people and through reading about the geographic region, the climate, the politics of western irrigation, and the cultural history of the Pyramid Lake Paiute Tribe. The narratives describe the last several years of a seven-year drought, 1987–1994. Although a series of wet winters and a "one-hundred-year flood" in 1997 have restored some of the river's integrity, most climatologists who know this area attest to the utter unpredictability of forecasting wet or dry cycles. Thus the book's focus remains on the human manipulation of arid lands.

About the Truckee River/Pyramid Lake Project

In 1988, Robert Dawson and Peter Goin began collaborating on a photographic project on the Truckee River and Pyramid Lake, which led to the book project, *A Doubtful River*. We realized that this study of water in the West needed to focus on an entire watershed rather than on the individual parts of water systems. To understand the dynamic and sometimes conflicting relationships between the cultures of this region, we physically followed the river. From 1988 to 1994, we walked, drove, and flew over all parts of this complex piece of western hydrology. In addition to photographing the river, we examined the urban, ranching, and Indian cultures and their relationship to the Truckee. Although some photographic work was completed separately, we, the photographers, worked mostly together in the field. Working together was important because much of the development of the project took place while driving through the western landscape. By allowing time to photograph, develop prints, and learn from those photographs, we were able to learn from each other as well as learn from the landscape. Days were spent together discussing what we saw, what we hoped to do in the project, and how our photographs could be useful in understanding this place. (Please note that the work of each photographer can be identified by his initials in the caption.)

It soon became apparent that another voice should articulate in writing what could not be presented visually. Early in the project, Mary Webb began examining the personal stories, the complex history, and her own relationship to this region. In doing so, the project broadened, became deeper, and, like the river itself, gathered a momentum from our combined energy and insight to help bring this effort to its final expression as this book.

In 1994, the Library of Congress in Washington, D.C., collected an entire set of 530 images from the Truckee River/Pyramid Lake Project for its permanent collection, and selected images were included in the Library of Congress's publication on its collection, *Eyes of the Nation*. In 1995, work from the project was exhibited at the Washington Center for Photography and the Troyer, Fitzpatrick, Lassman Gallery in Washington, D.C. Robert Dawson and Peter Goin participated at that time in a lecture and panel discussion about this project at the Corcoran Gallery of Art.

4. Drying reservoir, western Nevada. [rd]

A Season of Drought The Truckee River

In a season of drought, the river is a slowly dying vein of life. I sit in my cool, dark basement, facing the glow of my computer screen, and hear the hiss of the sprinkler next door. It is June 1992, the sixth summer of drought. My neighbor waters, early each morning, diminishing the river. Her efforts to maintain a green lawn in the desert represent our historical response to arid land and our possessive attitude toward the Truckee River, the most precious gold in this Great Basin.

Despite Reno's arid climate, the city shimmers like an emerald with its transplanted trees and grasses. These shade trees and lawns intersperse with native cottonwoods and willows, mapping the flow of the Truckee River. One hot June morning my neighbor watered her lawn, telling me the drought concerned her. Unlike many residents, she grew up here; she has seen the ebb and flow of wet years and seems confident that they will return. She shuns the desert plants, spindly Mormon tea and rabbit brush, that would thrive in her yard; she says, pointing the hose at stubborn brown patches, "This is a *meadow*, not a desert: Truckee *Meadows*."

To someone unfamiliar with the Great Basin, water is a given. But in this high desert region of western Nevada, rainfall drops below seven inches a year on average. Reno lies in a desert valley at about 4,500 feet; the area known as the Truckee Meadows encompasses the floodplain of the Truckee River, including the cities of Reno and Sparks, where population has increased by about 25,000 people from 1990 to 1996. According to the 1990 Census, population in that year was just under 200,000; it is projected to reach about 234,000 by 2000. Geographic features, most prominently the Sierra Nevada to the west, shape this valley into an oblong bowl. The Carson Range, a spur of the Sierra Nevada, rises some 9,000 to 10,000 feet, creating a rain shadow and blocking moisture that travels east from the California coast. Although these rugged mountains are watered by many small streams, the two primary rivers in western Nevada are the Truckee and the Carson.

Water from the Truckee and Carson Rivers rises in California but flows into western Nevada. Unlike other western rivers, which drain into the Pacific, the Truckee and Carson Rivers terminate inland, in desert sinks or lakes. The Truckee, for example, emerges from

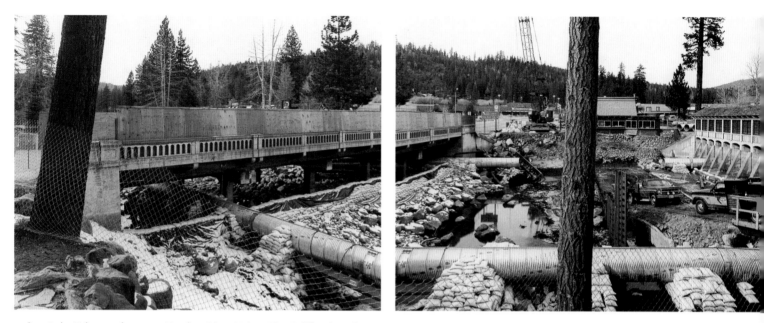

5, 6, 7. Lake Tahoe outlet gates, Truckee River, Tahoe City, California. [rd]

alpine Lake Tahoe and the pine tree–clad Sierra and flows one hundred miles or so to Pyramid Lake in the desert, linking two disparate countries: mountain and desert, watered and arid.

Lake Tahoe, seen from the air, resembles pretty blue tea sloshing around the rim of a mountainous white teacup. A friend of mine recently described it that way, recalling the perspective gained from a plane at 9,000 feet in the air. Lake Tahoe seems suspended at 6,500 feet above sea level, surrounded by forests of pine and fir. Following the Truckee River from its source near Lake Tahoe to Pyramid Lake provides a dramatic change in climate and geography. Mountains drop precipitously to the east, and the river follows rugged canyons; the trees thin, and suddenly the open brown hills stretch out. The Truckee finally empties into that desert lake known by its distinctive pyramid-shaped rock formation.

Symbolically and historically, Lake Tahoe, with its trees and snow-covered peaks, has drawn us up, out of the Great Basin, away from the desert. This "upward" migration of

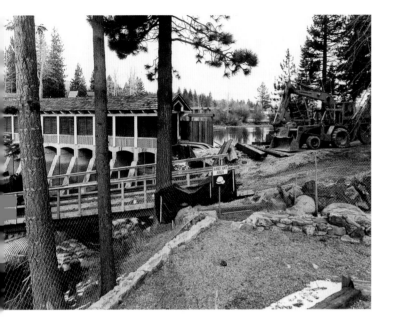

tourists and locals demonstrates in microcosm our historical response to the desert landscape: it can be a place that terrifies and repels us with its scorpions and sagebrush. We do not feel welcomed by the expanse of empty, treeless, alkaline landscape. An 1876 newspaper account in the *Nevada State Journal* captures this comparison between Tahoe and Pyramid:

> No two objects in nature of the same name, probably, can present so many contrasts as Tahoe and Pyramid Lakes; the one pouring its pure, wholesome waters by the Truckee river [sic] into the filthy sink of the other; the one elevated 6,429 feet above sea level into the cool cloud land, the other depressed 3,000 feet into the treeless plain, scorched by the glaring sunlight; the one bordered by bright meadows and dense evergreen forests, the other rimmed by alkali flats and bold reaches of sage brush; the one a source of unmeasured wealth to the cities of Nevada through its forest and meadow products, the other utterly worthless, a horrid incubus resting upon the fair

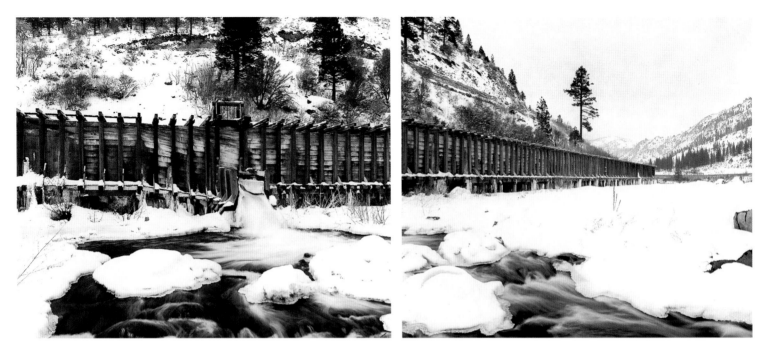

8, 9. Historic wooden irrigation
flume, snow and ice, Truckee River.
[rd]

face of the state; the one attracting to its shores on all sides thriving villages occupied by cultivated and happy people, the other presenting a smooth shoreline of 120 miles, broken by only one little grove of cottonwoods, the wretched shelter of a small band of savages, the vanishing Piutes [*sic*].

To understand the complexity of water in the arid West, consider the terrain and climate of Nevada. A rugged landscape, the Nevada topography rises and falls from range to basin or valley. Elevations vary from sea level to over 13,000 feet; the air is clear and dry, the scant moisture arriving mostly as snowfall in winter, even in desert valleys. The word *nevada* is Spanish for snow-covered: Some of Nevada's high mountain peaks remain snowcapped throughout some years (Wheeler in the east, Boundary in the west), but dramatic winter storms often leave a dusting of snow over much of this high-desert landscape. According to the *WPA Guide to 1930s Nevada*, "Arid Nevada is a phrase used only by those who do not know the State. Meadows so densely covered with wild iris that they resemble lakes, roadsides banked with the native wild peach . . . late snowfields splashed with the brilliant red of snowplant, mountain trails almost obscured by the profusion of blue lupine, red Indian paintbrush and wild rose, . . . this is the true Nevada."[1] Although this Great Basin desert holds within its apparently hard and brittle terrain the elements of such colorful displays, many nineteenth-century emigrants saw only a vast and hostile space to cross. No doubt they carried European notions of beauty, an aesthetic appreciation

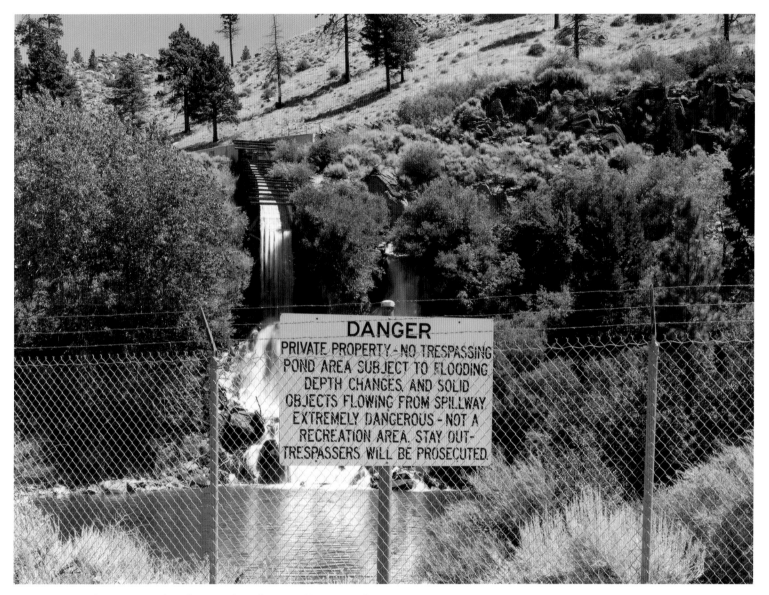

The sign in the image reads:

DANGER
PRIVATE PROPERTY - NO TRESPASSING
POND AREA SUBJECT TO FLOODING
DEPTH CHANGES, AND SOLID
OBJECTS FLOWING FROM SPILLWAY.
EXTREMELY DANGEROUS - NOT A
RECREATION AREA. STAY OUT -
TRESPASSERS WILL BE PROSECUTED.

10. "No Trespassing." Danger sign along Truckee River at spillway west of Reno. [pg]

11. Storage along the Truckee River: exposed car skeleton at bottom of Prosser Creek Reservoir, California. [pg]

12. Stampede Reservoir. This reservoir was built in 1970 by the U.S. Bureau of Reclamation. It impounds up to 226,500 acre-feet of water and is primarily used to store water for Pyramid Lake and for flood control. [pg]

13. Low water at Boca Reservoir. Built on the Little Truckee River, just upstream from the confluence of the Little Truckee and the Truckee Rivers, this reservoir was completed in 1937. It too was built by the U.S. Bureau of Reclamation for irrigation of the Truckee Meadows. Around the first part of the twentieth century, ice was harvested from Boca and shipped by rail to Virginia City and to San Francisco. [pg]

14. Prosser Creek Reservoir. Built on the north side of Interstate 80, this reservoir was completed in 1962. It serves primarily for flood control in the Truckee Meadows, but is also part of the Tahoe-Prosser Exchange Agreement. This agreement, according to the *Truckee River Atlas*, "is one of the complex series of water right constraints that govern operation of the Truckee River. . . . [It] provides for the release of water from Prosser Reservoir to meet water right demands from Lake Tahoe. The agreement thus allows more water to remain in Lake Tahoe in summer months, so flows to sustain the Truckee River fishery immediately below the lake can be maintained for longer periods" (p. 19). [pg]

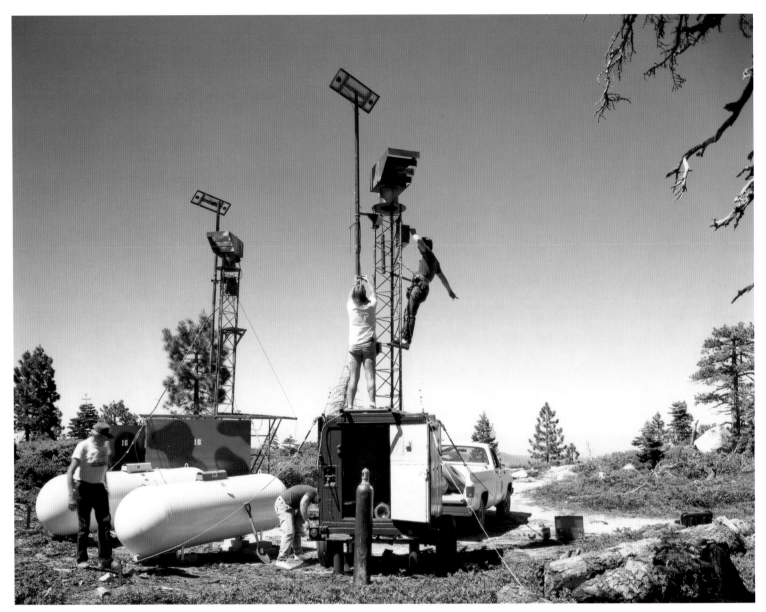

15. Technicians from the Desert Research Institute in Reno, Nevada, dismantle one of twenty cloud-seeding generator sites. Left to right: Monte Stark, Greg Adams, Tom Swafford, and Steve Batie. These generators are located throughout the Sierra Nevada, with nine sites near Lake Tahoe, five sites near Bridgeport/Walker, and six sites near Elko, in eastern Nevada. These generators release silver iodide particles into the atmosphere during storms to enhance snowfall amounts. The seeding increases snowfall by 10 percent to 15 percent in the target area. Cloud-seeding activities are suspended during high wind or avalanche conditions, when the snowpack has already reached levels well above normal depths, and when unusually warm storm systems might cause flooding by melting the existing snowpack. Seeding operations cease during peak holiday traffic periods as a convenience to travelers. The Desert Research Institute is a nonprofit statewide environmental research division of the University and Community College System of Nevada. [pg]

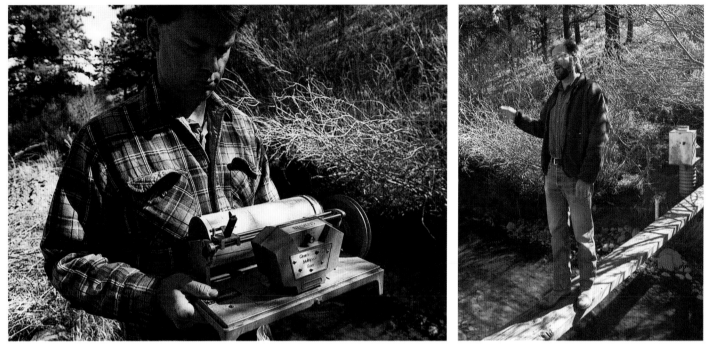

16, 17. Chad Blanchard and
Jeff Boyer, hydrologists from the
Federal Water Master's office in
Reno, inspect a water gauge along
the Truckee River. Although the
irrigation ditches in the Truckee
Meadows are owned by private
companies, the Federal Water
Master's office sends hydrologists
twice weekly during irrigation
season to measure flow rates in
the ditches. [rd]

for lush greenery and well-watered terrain. Perhaps they had read the words of naturalist John Audubon, who had passed through the Nevada desert and called it "a doubtful country." Like Audubon's, our modern eyes have not yet adjusted to shades of brown, may not see the beauty of the delicate, trumpetlike sego lily poking up through the dry earth. And like their contemporary counterparts, California-bound emigrants were both awed and terrified by this cheerless and lonely land. To the native inhabitants, the Northern Paiutes, however, these vast expanses of sage and saltbush meant life itself. Traditional hunting and gathering methods used by Paiutes depended on that same emptiness for the life-sustaining grasses, piñon trees, and scarce water that emigrants found unsettling.

In the last half of the nineteenth century, cultural clashes between natives and newly arriving whites set in motion disputes over land and water use that originated, to a large degree, in how this doubtful country is *seen*. Euro-American emigrants brought with them attitudes and assumptions that maintained Americans' right to "fill up the 'vacant' land of the Western Wilderness."[2] Western literature scholar Tom Lyon points out, "The perceived distinctiveness of the individual self, and man's separateness from the rest of the world, were given what amounted to cosmic sanction in Christianity's theology of special creation. As success reinforced the Western mentality . . . a certain heedlessness [toward the environment] also became characteristic."[3]

The American desert has offered a kind of paradoxical vision to us, the emigrants and

18.
Roads, train tracks, and Truckee River. The arrival of the railroad in the Truckee Meadows spelled further disaster for the Pyramid Lake Paiutes. After the General Allotment Act of 1887 was passed (which proposed breaking up reservation lands to determine "excess" lands that might be available for white settlement), Paiutes were squeezed off parts of their reservation. Once the railroad arrived, Paiutes lost the most arable of their reservation land, near Wadsworth. [rd]

travelers of the late twentieth century: An exhilarating openness in its spacious and majestic vistas and a feeling of unrestrictedness in those barren mountains greet those of us who might explore their lavender- and ocher-tinted interiors. But despite our advanced technology, the desert's extremes hold sway over us. In contrast to our predecessors, we drive across the miles of alkali in air-conditioned automobiles, marvel at the harsh and inhospitable land, and hope our tires don't flatten before the next town.

The diary of nineteenth-century emigrant Sarah Royce provides us with a record of what she and her family experienced in their desert crossing. Mrs. Royce, with her husband and daughter, left Council Bluffs, Iowa, heading west for the Sierra Nevada and gold country on June 10, 1849. That same year, some 22,000 emigrants with perhaps 60,000 livestock had traversed the trail, decimating what little grass there was to sustain the animals. As her party crossed the desert, Mrs. Royce describes not only the hardship of traveling but the horror of losing their way in the dreaded Forty-Mile Desert, the longest stretch of waterless desert along their journey. Missing a mark in the trail, the party was forced to backtrack through endless sand and sagebrush. The combination of exhaustion and fears of starvation and thirst brought about several almost-mystical visions for Mrs. Royce, who at one point sees a mirage:

> It was moonlight, but the gray-white sand with only here and there a sage-brush looked all so much alike that it required care to keep the road. And now, for the first time in my life, I saw a mirage; or several repetitions of that optical illusion. Once it was an extended sheet of water lying calmly bright in the moonlight, with here and there a tree on its shores; and our road seemed to tend directly towards it; then it was a small lake seen through the openings in a row of trees, while the shadowy outlines of a forest appeared beyond it . . . what a pity it seemed to be passing it by, when our poor animals had been so stinted of late.[4]

Later, when the party comes across the abandoned wagons of another group, their fear is heightened as they make out "the bodies of dead cattle and the forms of forsaken wagons as our grim waymarks."[5] Mrs. Royce's images pervade all of our cultural, stereotypical visions of death by desert. Historically we have viewed the desert as a place of desolation, of barren hills and unknown terrors. The desert, like the mountains, is a place of extremes, a place where death may claim us quickly, under the right conditions.

Similar fearful stories of violent deaths flow from the mountain snows just a few thousand feet higher and a hundred miles or so to the west. Like the Royce party, an earlier and less-fortunate group of emigrants in 1846 led by George Donner was headed for the gold country of California. The Donner-Reed party, a particularly prosperous group of eastern emigrants, drove a large wagon train; one wagon was so large it was called the

19. Cloud over upper Truckee River. [rd]

20.

The Crystal Peak Fire. A contractor for the National Forest Service was using a ground-clearing machine that sparked a fire near Stampede Reservoir on Thursday, August 4, 1994. Within six hours, the blaze spread to the east, endangering the town of Verdi along the California-Nevada border. This fire, named for nearby Crystal Peak, burned more than 6,000 acres, destroyed three homes, and cost in excess of $7 million to fight. This view looks to the northwest along the Truckee River corridor toward Verdi, Nevada, when the fire was most dangerous. [pg]

Pioneer Palace Cart, and it required eight oxen to drag it. The size of the Donner-Reed party's wagons, combined with the group's inexperience, led to eventual tragedy. A day's delay at their resting place in the Truckee Meadows exposed the party to an early snow, trapping them in a lower pass of the mountains. Many perished in the Sierra as a result of their dilatory attempt to cross during the autumn storm. By the time rescuers arrived from Sutter's Fort, only thirty-three of the eighty-one people remained alive. Many of those who did survive had cannibalized their dead, and a kind of horror still haunts Donner Summit. Today, driving over the 7,200-foot pass during a heavy snowstorm reminds us of that catastrophe more than a century ago.

Snow Stories Truckee and Lake Tahoe

My friends, who live upriver from Reno in Truckee, California, refer to Reno as "Drano." The image is deliberate; in their minds, waste runs downhill. Although this is often said jokingly, my friends point out that the Truckee River *does* run from high to low, from pure mountain snow to the desert below.

The town of Truckee takes its name from the river and from Captain Truckee, the Paiute guide who led a party of white emigrants from the Humboldt to the stream flowing through a pass in the Sierra. Truckee was established as a logging community; in the lumbering and mining boom of the 1860s, Truckee was a thriving, if "rough," western town. With the closure of the last mill, Truckee gave itself over to tourism. Located at the crossroads of the major routes to San Francisco and Lake Tahoe, Truckee supplies tourist traffic in every season; but in winter, tourism peaks with hundreds of thousands of skiers converging on the dozens of alpine and nordic ski areas in its immediate vicinity.

Winter's accompanying influx of city folk who get lost, can't drive in the snow, and muck up traffic sharpens that dual-edged sword of economic benefits. Locals and visitors alike growl at the endless number of cars backed up on Interstate 80 for ten or twenty *miles* on the day after New Year's as carloads of skiers make their way back into California.

The cars are dollar signs; an empty ski shop during a dry season's Saturday morning attests to the importance of snow. The employees draped themselves across countertops and spoke dreamily of snowpacks far away. "There's more snow in Central Park than there is in the entire Sierra," one murmured sadly during the dry January of 1996, the winter of the great East Coast snowstorms.

Reno's tourism, unlike Truckee's snow-dependent economy, survives, wet years or dry, and draws visitors with its National Bowling Stadium and Silver Legacy Resort, or the Great Reno Balloon Races. Perhaps the biggest attraction of the "Biggest Little City in the World" is Hot August Nights, a 1950s-style car pageant that closes out a summer of automotive events from recreational-vehicle shows to Harley-Davidson rallies. But while tourism may gird the economies of both Reno and Truckee, the neon glowing in that

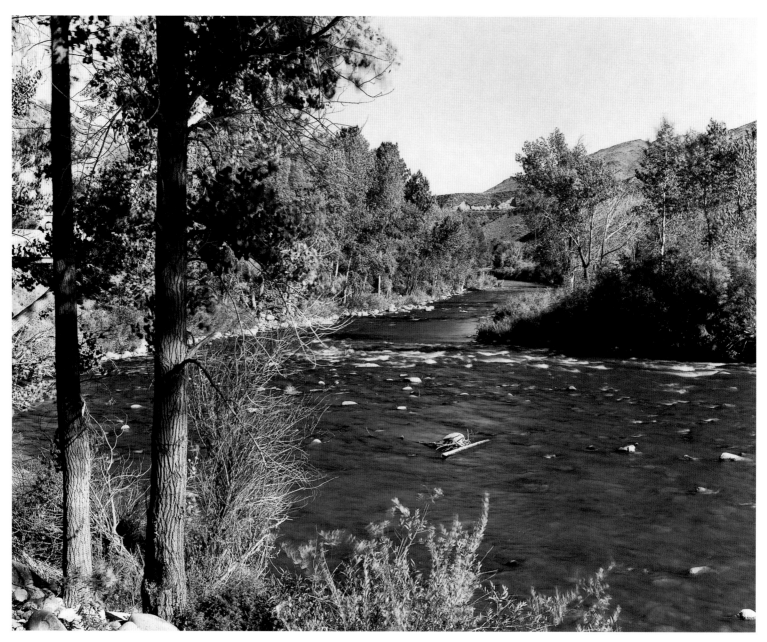

21. Best general view of Truckee River west of Reno. [pg]

hostile desert invites a different breed of tourist than do the sparkling water and snow-covered peaks.

Truckee and Lake Tahoe are skiing and sailing; Reno is video poker and all-you-can-eat buffets. Perhaps because of this difference, my friends see no irony in their tunnel vision, their protectiveness of Lake Tahoe, which is juxtaposed with an almost puritanical

contempt for the gambling, mining, and prostitution in Nevada's desert below. From glorious mountain summits where all is "bright with that brilliancy of sky and atmosphere, that blaze of sunshine," as Isabella Bird commented, it is hard not to look down on Reno, where glitz and what the ubiquitous billboards term "loose slots" epitomize a more sordid capitalism.[1]

My friend Robin commented as we sat on her deck, overlooking the spectacular blue of Lake Tahoe: "When I was a kid, you could paddle out into the Lake, dip a bucket two feet below the surface, and drink the water. It was that pure. Now look at it."

On that clear day in the drought-locked summer of 1992, docks stretched out to reach the receding water of Lake Tahoe as if in answer. The ceaseless sun shone down on Robin, her blonde hair pulled into a ponytail, tanned legs tucked beneath her while she gestured toward the azure water. A fourth-generation native of Tahoe City, California, Robin lives on the same land her great-grandfather homesteaded, just beyond the deck on which we sat. Her lawn below was neatly trimmed and green, bordered by flower beds bursting with mountain wildflowers: yellow columbine, larkspur, and tender purple violets.

"Fertilizers, erosion, and too many damned people." Robin enumerated the components that have degraded Lake Tahoe's clarity since the 1970s. On both the south and the north shores of Lake Tahoe, development has brought new housing and increased pressure on sewage systems and air quality. "And this drought has hurt, of course," Robin added. "Lake Tahoe, besides being Lake Tahoe, is Reno's primary storage reservoir."

Looking at "the crown jewel of the Sierra," as early historians called the lake, it was hard to fathom Lake Tahoe's many other roles. But Robin reminded me of Lake Tahoe's history, intricately tied as it is to Nevada's nineteenth-century silver boom. Damming the lake's outflows and logging the basin's timber provided the nearby Comstock Lode with two primary resources that were essential to its operation: logs and water. Beginning in the 1860s, extensive logging cut much of the old-growth timber in the Tahoe Basin to line the mine shafts in nearby Virginia City, Nevada. The logs were transported by flume and by damming stream flows out of Lake Tahoe. These early dams provided pioneers with a way to regulate the flow of water to transport the logs downstream and, later, to provide power generation and irrigation. A maze of conflicts surrounds the notorious dam at Tahoe City, where the Truckee River flows out of Lake Tahoe.

The Tahoe City dam was completed in 1913. Although owned by Sierra Pacific (the water provider for Reno and Sparks), it is operated by the Truckee-Carson Irrigation District for the U.S. Bureau of Reclamation. The federal agency's involvement stemmed from its early-twentieth-century promises to provide irrigation water to downstream Newlands Project farmers. The infamous "water wars," skirmishes between shoreline property owners at Lake Tahoe and farmers downstream, culminated in several incidents

22, 23, 24, 25. 1991 Miss Truckee River Beauty Pageant and River Race, Mayberry Park. [pg]

during the dry span between 1924 and 1935. In these drought years, as in the summer of 1992, water from Lake Tahoe did not flow over its natural rim and into the Truckee River. These early battles over drought-impaired Lake Tahoe pitted lakeshore residents and conservationists against Nevada interests. In 1930, a group from Reno sent an armed brigade, along with a steam shovel, to dig a diversion trench to the rim of Lake Tahoe.

Although Robin and I joked about the groups of Nevada farmers who had threatened to dynamite the dam at Tahoe City, our humor was laced with worry. A whining orchestra of backhoes reminded us that new construction, both around the lake and in Reno, exponentially increases the demands on the Truckee River system.

"Where does it stop?" Robin asked. She recalled the grim statistics in recent dendrochronological studies: Drought periods in previous centuries appear to have lasted much longer than six or even ten years. Twenty was not unusual; in fact, the twentieth century has been characterized by above-normal rainfall. These dry years exacerbate the increased need for water, both locally and downstream in the Truckee Meadows; but moreover, they underscore the unpredictable nature of western weather patterns.

A blend of machismo and quiet grace manifest in Robin, who makes her living as a part-time archaeologist in summer and avalanche guide in winter. Her life focuses on survival in the mountains; both her passion for the wilderness and her strong skiing led her to volunteer her time with the Tahoe-Nordic Search and Rescue Organization. Robin, like the other members of this nonprofit group, spends cold hours at three o'clock in the morning, skiing into deep canyons by headlamp, looking for the less-prepared, the un-

lucky, or the out-of-bounds skiers who lose themselves in the snow. She romances the risks they take in these search-and-rescue outings because, in her words, "search and rescue is one way we can use these arcane skills for someone else's benefit, instead of just our own pleasure."

To someone who values the trappings of a secure job (me), Robin's life is enviably simple. She owns neither television nor VCR; she drives a twelve-year-old Subaru. Her prized possessions include several doorstop-sized pieces of jade cut from the Alaska coastline, souvenirs of a year she spent living there. Although she never knows what jobs will be available in the coming season, she finds time to offer free ski lessons to children.

When I visit with Robin—when she takes me on little-known backcountry ski tours or hikes—I depart with the sensation that I have met a reincarnation of John Muir. Our friendship is founded on a shared passion for nature, which flourishes even in adverse weather. Robin tempts me with her contagious enthusiasm to ski up arduous and icy slopes, to test my own limits and find that I can negotiate the terrain. Once, on the winter solstice, we ascended the road to the summit of Mount Rose for a look at what she called "the shadow of the world" at sunset, the creeping darkness blanketing the basin and ranges to the east. As the shadows lengthened and turned blue in front of us, the snow behind us glowed pink, illuminating for those last moments of the shortest day the life-giving water that would flow into the drainages of the Truckee come spring.

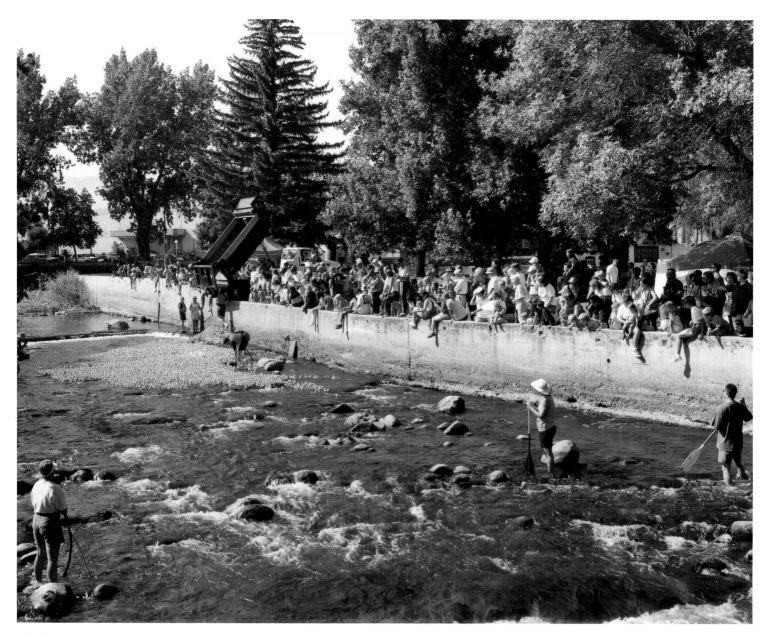

26. The Great Truckee River Duck Race, Saturday, August 28, 1999. The Nevada Make-A-Wish Foundation's™ annual fundraiser at Wingfield Park in Reno releases 15,000 "adopted" rubber ducks into the Truckee River. The ducks race about six hundred yards, and the first nine to reach the finish line win prizes (for their "parents") ranging from home improvements to shopping sprees. The Make-A-Wish Foundation's president and CEO, Bill Belcher, reports that this fundraising event occurs twice a year in Nevada, once in Elko (in June, on the Humboldt River), and once in Reno on the Truckee. Make-A-Wish Foundation, in its seventeenth year in Nevada, provides opportunities for terminally ill children (ages 2½ to 18 years) to have their wishes granted. The foundation will grant thirty-eight such wishes in 1999, from trips to Disney World to computer purchases for children who are facing life-threatening illnesses. The Truckee River Duck Race should raise upwards of $50,000 for the Make-A-Wish Foundation, whose annual budget is $130,000. The average cost of a wish is about $3,000 to $4,000, according to Bill Belcher. [pg]

Truckee River Canyon Stories Storage and Use

Adaptation is the covenant that

all successful organisms sign with

the dry country.

—Wallace Stegner,

"Living Dry"

Imagine being in charge of a river. One man in Reno oversees every drop of Truckee River water as it flows from Tahoe City, past the town of Truckee, along the pulsing artery of Interstate 80, to arid points east. Since 1984 when he was appointed to the position of Federal Water Master, Garry Stone has supervised the dividing of the Truckee River. The Water Master, an officer of the U.S. District Court for the State of Nevada, is charged with regulating Truckee River waters. To do so, he has become intimately familiar with the bewildering number of mandates governing the river, as well as how those regulations affect water users from the Nevada state line eastward. Garry Stone regularly acts as expert witness for the federal government in water disputes around the West. Our river system, he told me, sets a precedent for the rest of the nation: The Truckee River's bistate flow, its diversion via Derby Dam into the Newlands Project, and its eventual termination in Pyramid Lake on the Paiute Reservation make it a model of western water complexity.

Although disputes over water rights existed before the twentieth century, the building of Derby Dam propelled the major conflict over Truckee River water. But even before the Newlands Project, the river had been diverted by early Euro-American settlers who created an intricate series of ditches. This sophisticated delivery system had not addressed questions of interstate usage and had relied on the doctrine of prior appropriation to settle disputes. Prior appropriation, as the name implies, is based on the premise that land and water are separable. "Water rights are acquired when a person first uses water for a socially recognized purpose, and his legal right dates from that diversion and use."[1] In the case of Truckee River water, a party who owns a water right has the right to use that water as long as this use is beneficial. Not putting that water to beneficial use, or not using that water at all, means the water-right holder is subject to forfeiture. In times of shortage, the person with the earliest priority date gets to use the most water.

To understand the Federal Water Master's primary job, carrying out the Orr Ditch Decree, visualize the maze of storage basins and flume systems that hold and direct Truckee River water. Altogether, the Truckee River is fed by or stored in seven lakes, creeks, and reservoirs: Lake Tahoe, Donner and Independence Lakes, Martis Creek, Pros-

27, 28, 29. Smog: winter view of pollution and new development from the hills above West 7th Street, looking east, Reno. [pg]

ser Creek Reservoir, and Stampede and Boca Reservoirs. The Orr Ditch Decree actually began as a lawsuit filed by the U.S. Bureau of Reclamation in 1913. The bureau wanted to "confirm water rights held for the Newlands Project" to ensure that downstream farmers in Nevada would have adequate water from the Truckee River. The 1944 settlement, known informally as the Orr Ditch Decree, adjudicated Truckee River water rights: "A friendly suit," the case of *U.S. v. Orr Water Ditch Co. et al.* sought to "discover all the legitimate existing claims under state law, so it [the government] would know how much unused water it could justly claim for the Newlands Project."[2] The Orr Ditch Decree enforces provisions to various individuals along the river; these include the water arm of the local power company, Sierra Pacific, which provides for municipal and industrial uses of water; farmers who irrigate off the main Truckee River as well as the Newlands Project; and the Pyramid Lake Paiutes.

Dividing the river requires the water master to regulate its flow into lakes and reservoirs upstream of Reno. Using gatekeepers, the water master can store water in the

reservoirs or (when the gates are opened) let more water flow into the river. This is done to meet Floriston Rates, the Orr Ditch Decree–mandated minimum flow along the river. This rate of flow, 400 cubic feet per second, ensures water for municipal use in Reno as the dry summer months get under way.

It was February of 1993 before I actually met Garry Stone, though we had spoken over the phone during the driest months of 1992. The winter of 1992–1993 had already broken records in the West. The storm track pushed dry weather to the south, interrupting the seventh year of drought with a series of very wet storms that began in December. Garry had invited me to attend a meeting of the governor's Drought Task Force, where the topic would be snowpack and how that snowpack might affect the river's flow come spring. A large snowpack, some forty feet, waited up high for spring's thawing to send a volume of water flowing down the thin Truckee. It had been a good winter; for some who were relative newcomers to the area, it was an overwhelming amount of snow—"This is a *desert*," they said. "And what happened to that drought?"

30. Virginia Street at night,
circa 1945. Peter Goin Collection.

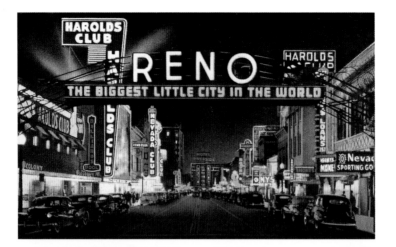

31. The Nevada Club, Reno. [rd]

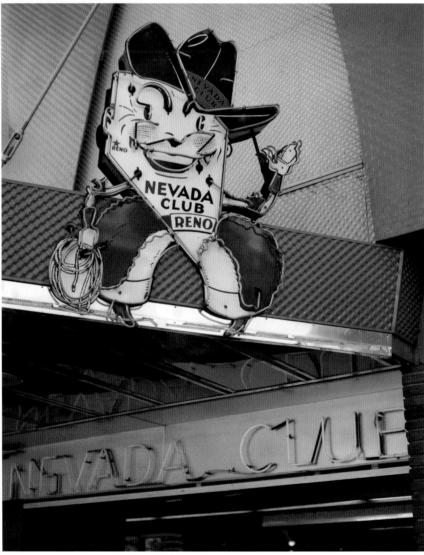

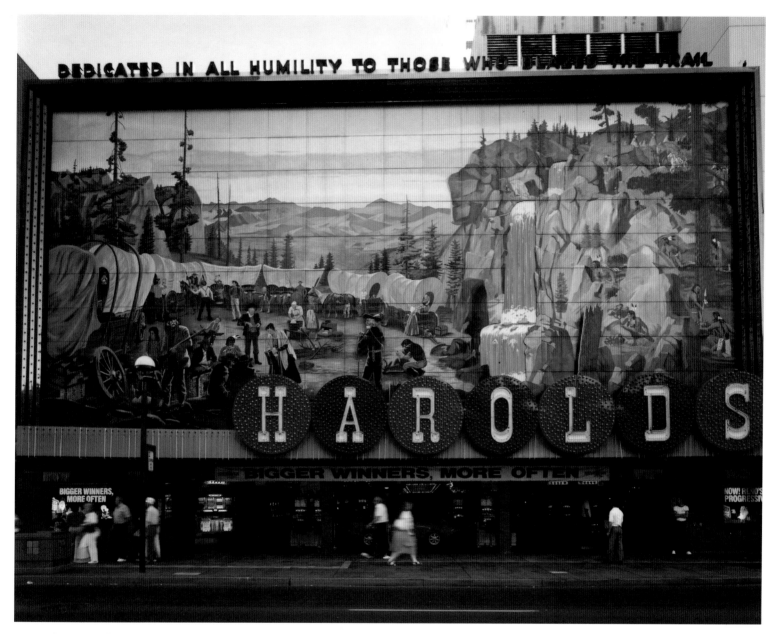

32. "Dedicated in all humility to those who blazed the trail." Mural formerly fronting Harolds Club, Reno. Executed circa 1949 by Theodore McFall and staff, of Shawl, Nyeland, and Seavey Advertising Agency, San Francisco. The 30-by-80-foot mural was installed on the building's exterior and is made of 30-by-30-inch enameled steel plates. Mirrors and moving parts give the impression of movement behind the waterfall and campfire. As of September 1999, plans to demolish the Harolds Club building (now owned by Harrah's) were set to commence in October 1999, necessitating the removal of the mural. Harrah's spokesperson Kerri Garcia stated that the mural will be stored for preservation. [rd]

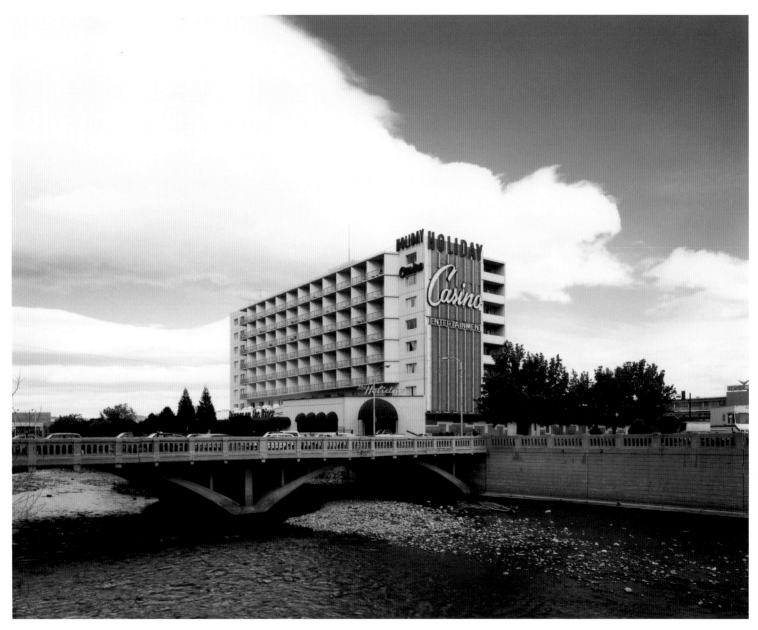

33. Clouds and the Holiday Casino, Reno. [rd]

The mood at the meeting was convivial as the state climatologist joked with other water experts from the National Weather Service and the state engineer's office. These were relaxed-looking men, dressed in jeans and flannel shirts—they were clearly at home *outdoors*; but with all the good news about precipitation, they were equally at ease in front of the media. Their reports indicated that snowpack was anywhere from 145 percent to 195 percent of normal. Reno had had more snow on the ground, from December through

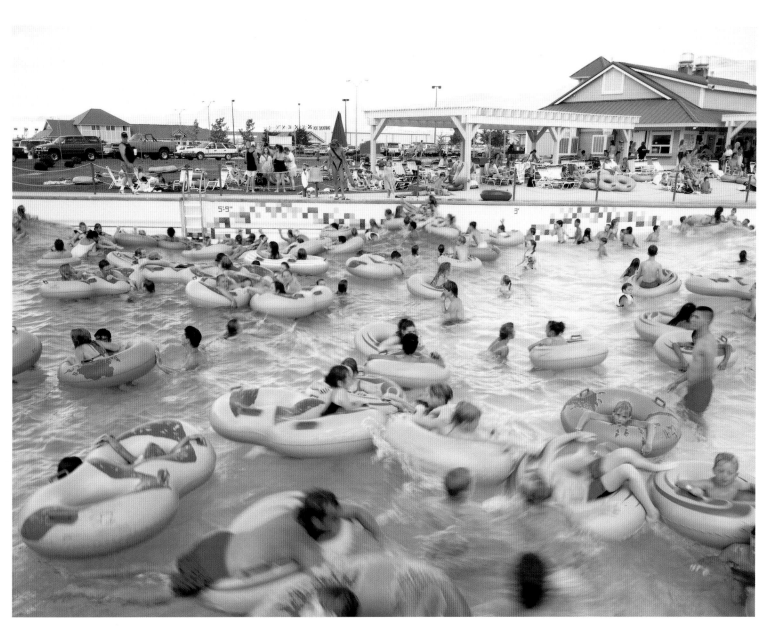

38. Wild Island along the Truckee River, Sparks. [pg]

Josiah, "As one travels by the familiar central route still farther west, one reaches the valley of the Humboldt River, that kindly stream whose general westerly trend made the early overland migration possible."[3] It was along the Humboldt route, south of where the river once sank into a meadow, that Garry's hometown of Lovelock developed.

According to the *WPA Guide*, "In 1908, the Humboldt-Lovelock Irrigation, Light, and Power Company, whose stock was owned largely by valley ranchers, built reservoirs that

39. The Aquarange, Hilton Bay, Reno: a human-made lake is transformed into a driving range over water. [pg]

would irrigate about 8000 acres of land. . . . Then, in 1934, construction of the Rye Patch Dam was begun by the U.S. Bureau of Reclamation."[4] Garry's father and grandfather both worked on the Rye Patch Dam, at the lower end of the Humboldt River. This river, like the Truckee, had been harnessed for irrigation since the 1930s. As a boy, Garry went with his father and grandfather on their tours of the water conservation district, where he learned about ditches and dams. His life in the desert had been spent surrounded by water and dealing with its diversion. After attending the University of Nevada in Reno, Garry chose to stay close to his family and to conservation-district work, moving first to the Carson Valley and then to Reno to work for then–water master Claude Dukes.

Dukes was actually the second water master; *his* father had been the first. Dukes became acquainted with Garry in 1967 when Garry took over as deputy over the Carson River. From that time until Claude Dukes's death in 1984, the two men worked closely, each overseeing the diversion and management of the two most-litigated rivers in the state.

The complicated apportioning of water has been the water master's job since Harry C.

Dukes, Claude's father, filled the position. The water master would "prepare technical recommendations," which were then used to provide for the delivery of water along the Truckee River.[5] A Pyramid Lake ditch rider's report from 1928 gives a flavor of how the system operated back then: "Irrigation start May 1st. Last Month the water in the canal was stock water: account on [sic] the river bank wash away by the flood last month. Which ruined the farmer [sic] watering places."[6]

The ditch rider's job was to patrol the ditches and take readings of how much irrigation water was being used. Today, ditch companies still employ riders and bill the recipient for the water; the riders check and maintain the ditches. The water master's office monitors water use and adjudicates any discrepancies. Today, hydrologists who work for the water master install recorders that mark water use. All summer, the recorders are checked weekly.

Still, with growing demands from all the users of water, the complexity of the water master's job intensifies. Quotas provided for Truckee Meadows irrigators have more "junior" (later) water-right status than either the Pyramid Lake Paiute Tribe or the urban users of water, and so are shut off first in drought years. As we talked in his office, Garry pulled out an enormous brown ledger with a listing of water rights dating back to 1860. "How do I tell these farmers, who have been irrigating with Truckee River water since their families settled here a hundred years ago, that I have to shut off their ditches? They ask me how come I can't shut off the water going to the new developments in town—they drive down here to my office and pass by acres of lawns surrounding new homes and shopping centers, all being watered. And yet, a couple of weeks before their cantaloupes will ripen, I have to turn off their water. They can't see the reasoning, but I have no choice."

I looked at the yellowing pages with names I recognized as old Reno families. The Truckee Meadows, from the town of Wadsworth near Pyramid Lake and westward, had been settled largely by Italian families, a few of whom still irrigate and grow crops along the Truckee River.

"You know," he said, "if I'd started this job in drought years, I'd be an English teacher at UNR."

"What about the Indians?" I asked, referring to the role of Pyramid Lake Paiutes in this increasingly difficult apportionment of the Truckee River.

"It's a damn shame," Garry replied. "You know, when I first started in this business, it was 1956. Back then, Pyramid Lake was just not considered important enough to worry about. I admit, that was the wrong attitude. But now, it's the farmers who are getting the short end."

In drought years during the early part of the century, water for irrigating tribal ranches

40. Helms Gravel Pit, Sparks, just north of Interstate 80 and the Truckee River. The pit was used by the Robert L. Helms Construction Company in the 1960s to excavate sand and gravel. Nearby (and just north of the Truckee River) is a tank farm used by ten pipeline, railroad, and oil companies to store diesel and jet fuel. In 1987, the state Environmental Protection Agency first became aware of an oil slick flowing from the tank farm and the adjacent rail yard. The 250-foot-wide slick lay on top of underground water and was seeping into the 120-foot-deep gravel pit to the east of the tank farm. In addition, the pit is located atop a huge aquifer underneath the City of Sparks. The flow of the aquifer shifted to the northwest, toward the pit and past the tank farm. Only this reversal of the aquifer's flow kept the seepage in the Helms Pit, where it formed a slick on water at the bottom of the pit and prevented the oil from reaching the Truckee River. The total amount of fuel leaked is estimated at anywhere between four and forty million gallons. The ten oil companies agreed to pay Helms Construction the $30,000 a month that it was costing to skim and remove the oil and pump the water to the river. The companies have also paid to have oil pumped out of the ground in the tank farm area. Helms had planned to turn the pit over to the City of Sparks, which would develop it as a lake and recreation area. Helms Construction filed for bankruptcy in the later 1980s, and plans for cleanup were halted while lawsuits brought by the State of Nevada and the City of Sparks determined who would be responsible for the damages.

Before that decision was reached, the New Year's Day Flood of 1997 caused flood waters from a nearby ditch and the Truckee River to flow into the pit, dumping more than 500 million gallons of water into it. The flooding eroded the roadbed under the westbound section of Interstate 80, closing the highway for several days. The city reached a settlement with the oil companies and began cleanup of the pit. The pit will be transformed in 1999, when the City of Sparks will open "Sparks Marina Park," a lake, complete with a two-mile jogging trail, picnic areas, an amphitheater, and family beaches with boat-launch facilities. The new lake is stocked with rainbow and brown trout; the City of Sparks hopes that the new marina will become a spectacular urban fishery. More than $3 million have been spent to make the steep banks of the former gravel pit more stable. [pg]

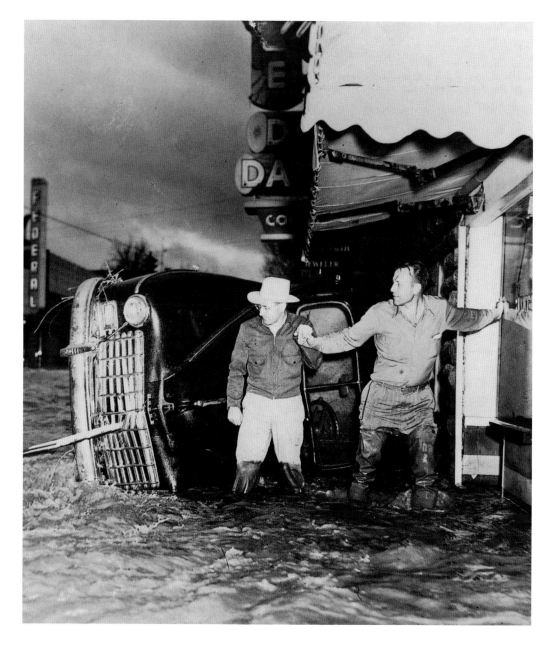

often ran out before it reached Pyramid Lake. The situation can be summarized in the words of a 1921 report by Indian Agent Trowbridge: "The Indians have a water-right, but being at the tail-end of the river, so to speak, they are unable to obtain their proper share of the water, all other water users on the river having first chance and there is no one in authority to make a just and fair distribution."[7]

The Paiutes' water rights, at the time of that notation, were apportioned on the basis

of agricultural and domestic use only; no allocation was in effect for maintaining the level of Pyramid Lake for the annual spawning of either the lake's world-renowned Lahontan cutthroat trout or the prehistoric cui-ui (pronounced "kwee-wee").

As Pyramid Lake declined and the Truckee River delta emerged, native fish populations could no longer migrate upstream to spawn in the Truckee River. Pyramid Lake's original Lahontan cutthroat trout is now extinct, although a closely related strain of the trout was reestablished in Pyramid Lake in the 1960s. Another fish, the prehistoric cui-ui was listed as endangered in 1967. Cui-ui fossils two million years old have been found in areas once occupied by the prehistoric Lake Lahontan; they are found nowhere else in the world. Both fish had been vital to the ancient Paiutes' culture, particularly the cui-ui, which formed the center of the Paiute economy. Only when Pyramid Lake reached its historic low level in 1967, and the native cui-ui was listed as an endangered species, were diversions from the Truckee River reduced by the first of several federal regulations and court orders known today as the Operating Criteria and Procedures, or OCAP.

I reflected on the many competing biota: fish, farmer, urban dweller. Although the farmers' uses had taken precedence during the first half of the twentieth century, public values were shifting and other voices were beginning to have their say. I wondered whether the attitude toward Pyramid Lake and the Pyramid Lake Paiute Tribe had actually changed all that much. During the drought conference, someone made a reference to the potential for spring flooding if any rain fell and melted the huge snowpack. If this were to happen and water flows exceeded the prescribed rate, the mechanisms of river operation—storage basins and dams upstream—would be unable to hold the runoff. I pondered this: Flooding would cause damage, yes. But wouldn't the water wind up in Pyramid Lake or further out in the wetlands? The answer was yes.

Leaving the water master's office, I walked into a brisk, clean wind that was blowing steadily from the west. Big lenticular clouds spilled over the crest of the Sierra, and I doubted the predictions for dry weather for that week. The sky had that wonderful indigo wash that it gets after a front blows all the smog out. The front, a fast-moving low-pressure cell, had brought a dusting of snow and a cold north wind that dissipated the grimy layer of smog capping the valley.

Because of the bowl shape of the valley, Reno, like Denver, develops inversions when stable, cold air sinks and becomes trapped over the city. Then dust, auto exhaust, and wood smoke pile up, stuck in the stagnant air. Two days before this drought conference, the air had been so filthy that "red" warnings—no burning wood, try not to breathe—were issued. Despite the apparant hiatus in the drought, the air would still remind us of the problems we encounter trying to live in such a place of limited resources, both water and, to an extent, air. We hadn't seen much blue in January and February—in addition to the

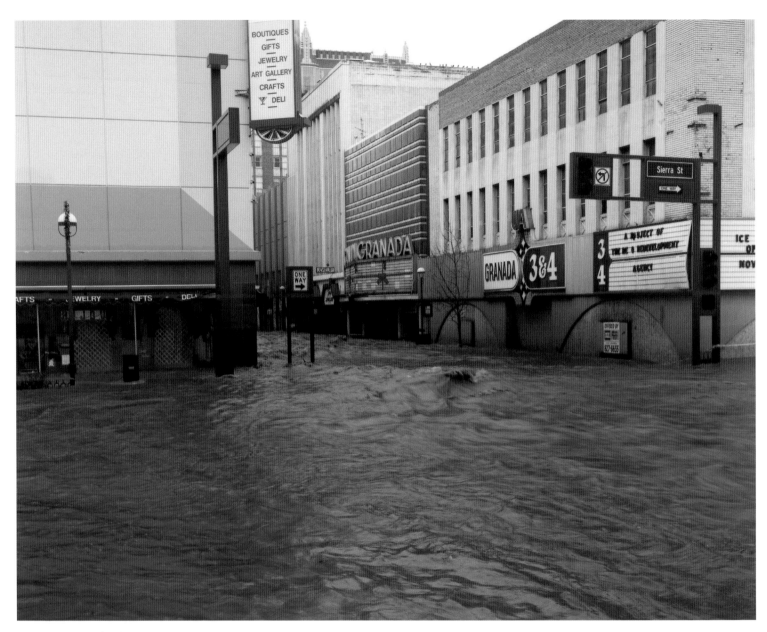

42. January 1997 flood. View looking down First Street at Sierra Street, Reno. This movie theater has since been torn down, to be replaced by a new theater complex. [pg]

smog, cold fog had settled into the valleys for weeks at a time, creating wonderful white displays of *pogonip*, a Southern Paiute word meaning "frozen fog." But as high pressure began to dominate the weather, the smog layer got thicker and thicker, until even the barest outline of the mountains was hidden.

The surge of cold wind was welcome as it cleared out the dirty air; I breathed deeply, wished I were going skiing, and walked home. I was thinking about how I had conjured

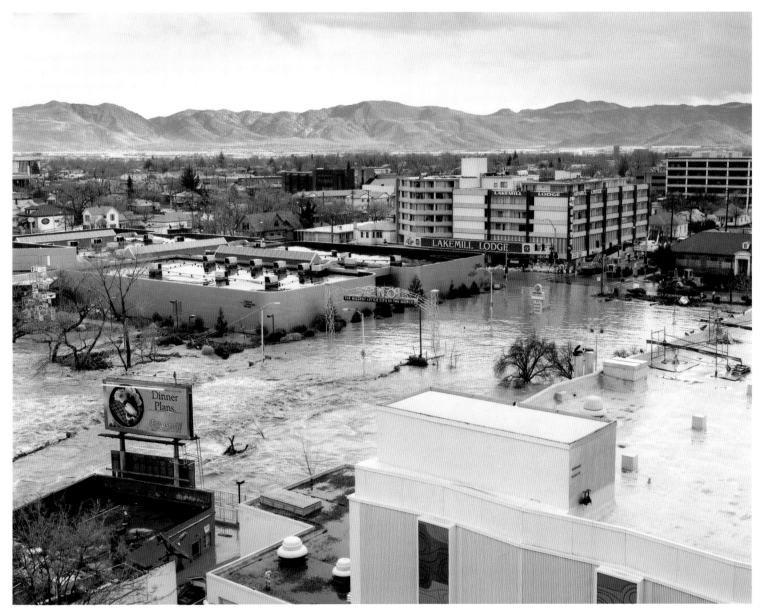

43. January 1997 flood. View looking south across flooded Truckee River; the Automobile Museum is center left. The old "Reno Arch" is on Lake Street, Reno. [pg]

the American West in my mind's eye since childhood. Despite the green-hued images of my midwestern upbringing, those desert scenes came alive when I read Edward Abbey's celebration of red rocks in *Desert Solitaire:* "There is something about the desert that the human sensibility cannot assimilate. . . . Transparent and intangible as sunlight, yet always and everywhere present, it lures a man on and on, from the red-walled canyons to the smoke-blue ranges beyond, in a futile but fascinating quest for the great, unimaginable

44. Bones on carpeting, homeless camp, Truckee River near Reno. [rd]

45. Homeless shelter along Truckee River near downtown Reno. [pg]

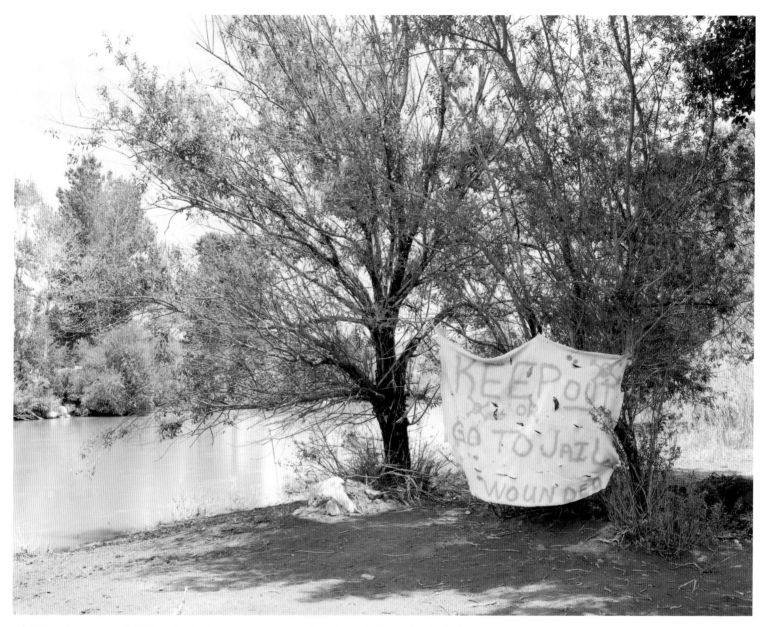

46. "Keep Out or Go to Jail Wounded" at homeless camp, Truckee River within Sparks city limits. [pg]

treasure which the desert seems to promise."[8] As Abbey points out, his words in *Desert Solitaire* memorialize a place that no longer exists; similarly, the open spaces within this urbanized corner of the Great Basin are rapidly closing. It is becoming harder to slake our thirst for vast stretches of space, blue sky, endless horizon.

And what started it all was us, of course. As young men (and women) hitched their wagons to stars and headed west, they moved themselves, their belongings, and their

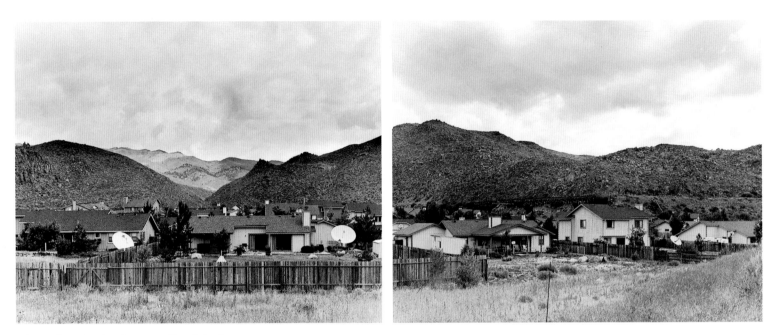

48. New housing development, Mogul. [pg]

European notions of beauty with them. To many of them, as to many of us, arid land held little value. In 1905, the first federally funded reclamation program, named for Senator Francis Newlands, began diverting Truckee River water. The underlying premise of the Newlands Project intimated that the water flowing in the Truckee River to Pyramid Lake, the home of the Pyramid Lake Paiute Tribe, was not used to its best advantage, that, in effect, it was wasted.

According to Martha Knack, "Anglo engineers and Western farmers asserted that the Truckee River had 'excess' water, that which had previously flowed down to Pyramid Lake. The Truckee Valley, they argued, offered little arable land where this water could be used advantageously." The Newlands Project commenced with the construction of Derby Dam, twenty-five miles upriver from Pyramid Lake. From that point, writes Knack, "the thirty-two mile–long Truckee canal would carry a quarter of a million acre feet of Truckee River water southward to the Carson River drainage." There the water would be stored behind

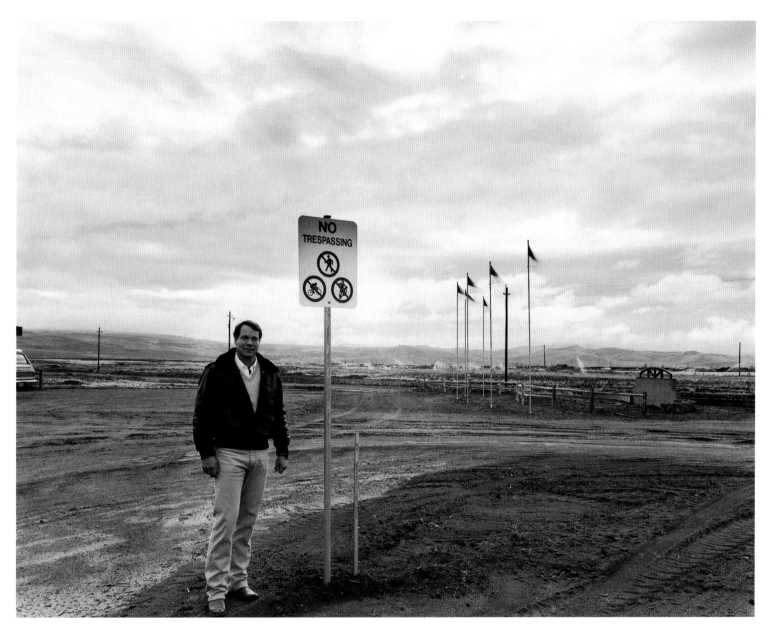

49. Developer of five-acre parcels, off
Pyramid Lake Highway: "We can develop
this area if we can get the water from
Fish Springs." The developer refers to
the transporting of water from Honey
Lake, California, a desert lake to the west
of Pyramid Lake. The plan was scrubbed
by U.S. Department of Interior Secretary
Bruce Babbitt. The proposed Honey Lake
project was deemed too damaging to the
surrounding environment. [rd]

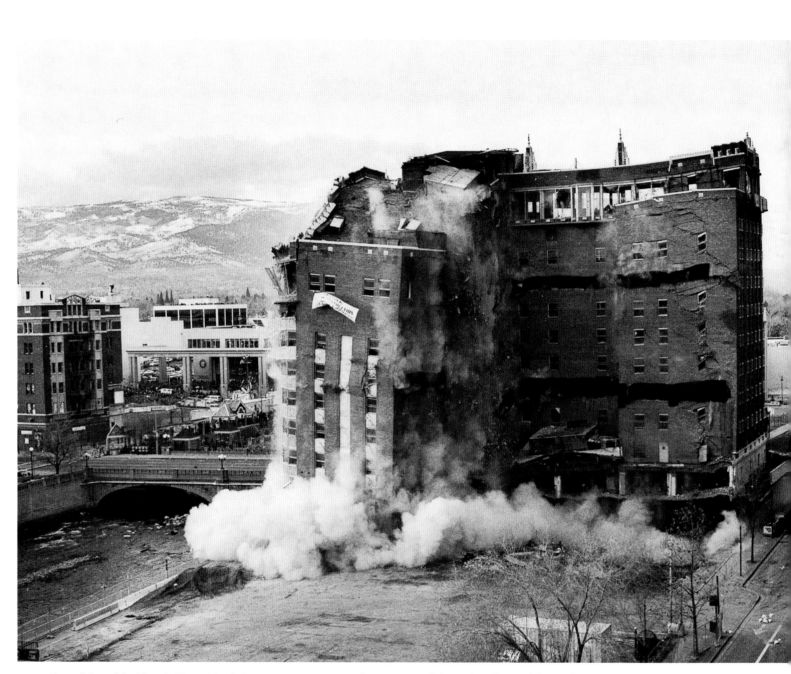

50, 51. Demolition of the historic Mapes Hotel, Reno, January 30, 2000. The Mapes Hotel, located on the north bank of the Truckee River, crumbles after its planned demolition on a clear, windless Sunday. Bricks, debris, and an accumulation of eighteen years of dust were imploded after the City of Reno decided to level the hotel.

The historic twelve-story Mapes, which opened in 1947, ushered in the era of modern gambling with Reno's first high-rise casino. The Mapes offered lodging, fine dining, and entertainment in the hotel's top-floor Skyroom. Locals remember the Mapes's spectacular views and the many Hollywood stars who stayed there. Clark Gable resided at the Mapes during the filming of *The Misfits*.

The Mapes closed in 1982, unable to compete with newer, larger casino-hotels. Years of contention followed, dividing city residents about what should be done with the hotel, which was located on prime development property next to the Truckee River in downtown Reno. The Mapes was named to the National Register of Historic Places in 1984, and preservationists campaigned to restore the architecturally significant art-deco building.

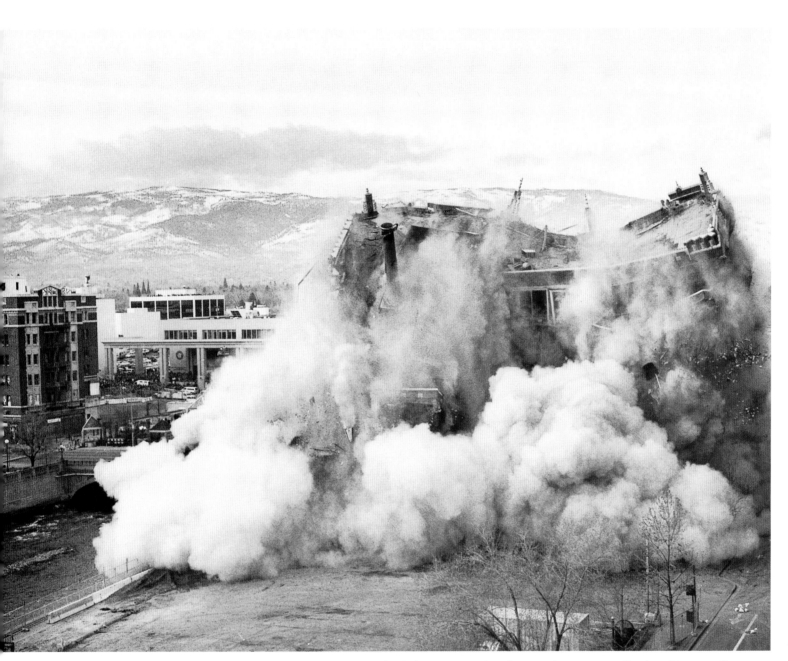

In 1996, the Reno Redevelopment Agency purchased the Mapes and solicited bids for renovation, but all proposals were eventually rejected because of their cost—the hotel would have needed more than $25 million worth of rehabilitation, from asbestos removal to correcting structural defects.

Meanwhile, the City of Reno had begun to focus its redevelopment efforts on sites along the Truckee River. In late 1999, the former Holiday Hotel was being remodeled into a larger casino with riverside restaurants and shops. The nearby Mapes property, bordered by Virginia Street, Reno's central artery, and the river, became highly desirable for its potential to foster further economic growth in the downtown area.

Finally, at the end of 1999, despite heated local opposition from preservationists and citizens who opposed the loss of this historic link with Reno's past, the City of Reno ordered the demolition of the Mapes. Artistically and historically valuable artifacts were removed from the building, including the art-deco sign bearing chaps-clad cowboys forming the M in *Mapes* and some of the floral-patterned concrete squares that decorated the building's exterior. Imploded by carefully set charges inside the building, the Mapes came down easily in only seven seconds, raising an impressive cloud of dust and sending bits of debris into the Truckee River. [pg]

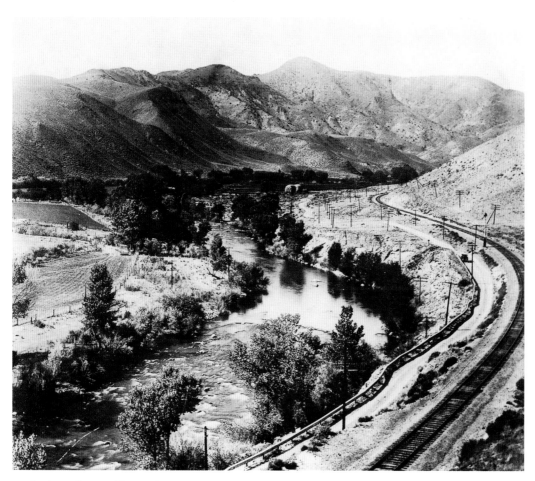

52. Lockwood, east of Reno, circa 1920. Courtesy Nevada Historical Society.

the Lahonton Dam until needed for irrigation. The high-desert land would then be reclaimed, available for agriculture.[9]

Senator Newlands's predecessor, Senator William Stewart, had proclaimed to Congress that the Truckee, Carson, and Walker Rivers wasted "at least ninety per cent" of their water by running into sinks. Like Senator Stewart, Newlands lobbied for the federal funding of the irrigation project that would divert Truckee River water.[10] Senator Newlands saw agricultural development of this arid state in two ways: as an alternative to the erratic cycles that predominated the mining-based economy, and as evidence of a sociopolitical agrarian ideal of small, independent farms to support the populace in the Jeffersonian tradition.

Newlands's vision of an agrarian West had begun with his own private irrigation company (the Truckee Irrigation Project), which had failed. But in 1902, under Theodore Roosevelt's administration, the Reclamation Act became law. Both Newlands and Roosevelt shared an admiration for John Wesley Powell, who had supported the idea of irrigat-

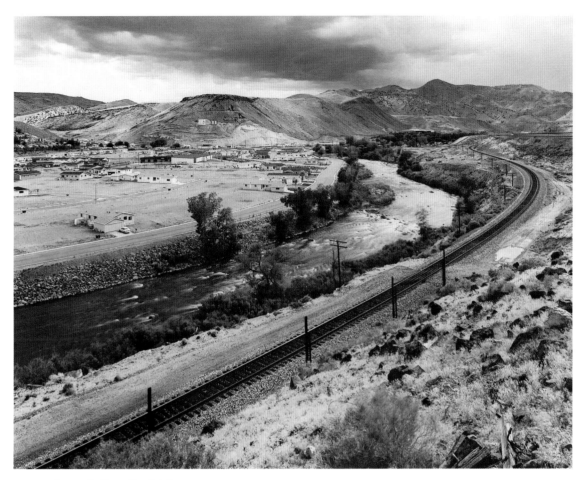

53. New homes built on floodplain,
Truckee River, 1989. [rd]

ing the arid West. Like Powell, Roosevelt was a conservationist, that is, one who believed in *using* western water. Roosevelt shared with Senator Newlands a desire to settle western states, and reclamation became the way to accomplish that task.

One problem the technocrats of Newlands Project had not anticipated was the sort of land they were irrigating. In many cases, soil was alkaline and drainage poor. According to Knack and Stewart, "Only after Derby Dam was completed in 1905 were the soils of the proposed farming area tested, and only then did officials discover the unpleasant truth. Although this was a desert area, the water table was shallow. With irrigation, the level of highly alkaline desert groundwater would rise still further. When it reached the bottom of the root zone of the domesticated plants, the crops would die. The more irrigation water applied, the worse the problem would become."[11] Eventually, the Reclamation Service installed more than one hundred miles of deep drains to help alleviate the groundwater problem, yet it has continued to limit the number of acres that could be farmed.

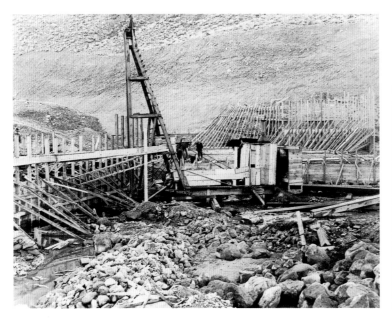

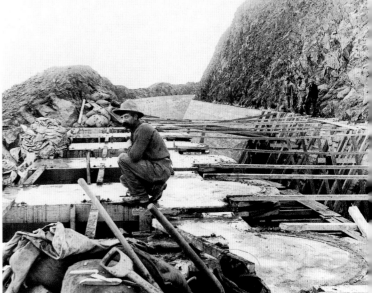

54. Newlands Project: U.S. Bureau of Reclamation project undertaken to dam the Truckee River at Derby Dam and transport its water to the Lahontan Valley for irrigation. Intake of Truckee Canal taken from a point just above the main dam. Credit: Walter J. Lubken, January 17, 1905. U.S. Bureau of Reclamation. Courtesy Nevada Historical Society.

55. Newlands Project: top of piers of Wasteway Gates on Truckee Canal. U.S. Bureau of Reclamation. Courtesy Nevada Historical Society.

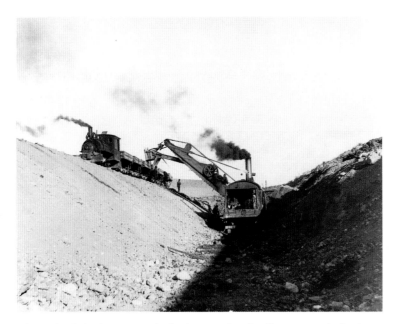

56. Newlands Project: steam dredge in operation, loading cars on the banks of the Truckee Canal. Credit: Walter J. Lubken, January 17, 1905. U.S. Bureau of Reclamation. Courtesy Nevada Historical Society.

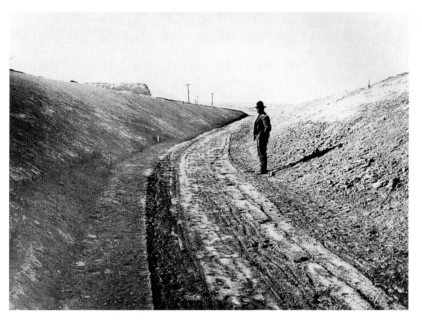

57. Man in Truckee Canal. Courtesy Special Collections, University of Nevada, Reno, Library.

Another problem immediately apparent (but entirely ignored) in the Truckee River diversion was the effect on Pyramid Lake. During the twentieth century, the lake's surface area has decreased by about 25 percent. Its elevation has dropped more than seventy feet. Nearly half (48 percent) of Truckee River water that would have gone to Pyramid Lake began flowing to the Lahontan Valley for farming. Pyramid Lake's elevation fell, exposing the Truckee River delta. Winnemucca Lake, Pyramid's ephemeral sister lake, began to disappear as dry years and diversions dehydrated the ecosystem. Although Winnemucca Lake depended almost entirely on the overflow from the Truckee River, in good years it supported a lush population of reeds and tules of all kinds that offered shelter to migratory birds passing along the Great Western Flyway.

Nearly a century after its inception, the Newlands Project has created myriad conflicts: The Lahontan Valley farmers, who farm irrigated desert land, have had to contend with the alkali in their desert groundwater as well as with infertile soils. Further challenges to arid-land farmers were legislated by Public Law 101–618, authored by Nevada Senator Harry Reid. PL-101 authorized the Bureau of Reclamation to alter and tighten the way in which Truckee River water is delivered to the farmers served by the Newlands Project, both in acre-feet (they get less) and in stringent requirements for conservation.

Urbanization of the Truckee Meadows, supporting growth in the cities of Reno and Sparks, takes from fifty thousand to sixty thousand acre-feet of water from the Truckee

River each year. Pyramid Lake cui-ui now rely on a dam, built by the Army Corps of Engineers, to swim upriver to spawn. But they are making a comeback, technology-dependent though they may be. The Pyramid Lake Paiute Tribe, as the result of the 1990 legislation, is beginning to reintroduce traditional cui-ui–based celebrations into their culture.

Despite consecutive years of drought from 1987 through 1992, one can stroll any neighborhood in Reno and be amazed, as my Los Angelean sister was during one particularly hot July day, at the verdant lawns, the shade trees, and thirsty, water-dependent landscaping. As Wallace Stegner points out in "Living Dry," what we do about aridity in our culture is to "deny it for a while. Then you must either try to engineer it out of existence or adapt to it."[12]

When my neighbor and her husband moved in, they went right to work on their yard. Each weekend they mowed, trimmed, weeded, and fertilized their lawn. They planted flowers. They proved, unlike me on the other side of the fence we shared, to be model homeowners. Approving smiles of the neighbors began to shine upon their tidy corner, an immaculately groomed expanse of green that hummed with the whine of their power mower.

Through the drought summers, the daily hissing of their sprinklers evoked my hostility. The Truckee River had disappeared in that summer of 1992. One hot August afternoon, Peter Goin invited me to join him while he photographed something unusual. We climbed under the Glendale Avenue bridge, which spans the Truckee River as it winds its way through urban Reno. There we chatted with and photographed a group of subcontractors hired by Sierra Pacific to dig a trench across the nearly dry riverbed. What they were doing, they explained, was directing the tiniest channel of water into the freshwater treatment plant that stands at Glendale Avenue. It was astounding to see exactly how dire the situation was and, moreover, to climb back to street level and observe the crush of five P.M. traffic as it chugged along, the passengers oblivious that their drinking water was perilously close to running out (see pl. 37).

In that summer of 1992, the sixth consecutive drought summer, Lake Tahoe was below its natural rim, which meant that no water would spill over the dam at Tahoe City into the river. The ultimate contrast, the greening of lawns within sight of the diminished river, seemed not to register with many people, particularly my neighbor. Although she was born and raised in this area, she does not understand the limits of a desert environment; she has much in common with the transplanted easterners who find the desert frightening. The diary of Sarah Royce certainly illustrates the dread with which this landscape was viewed; my neighbor's lawn, like others in the area, demonstrates our long history of

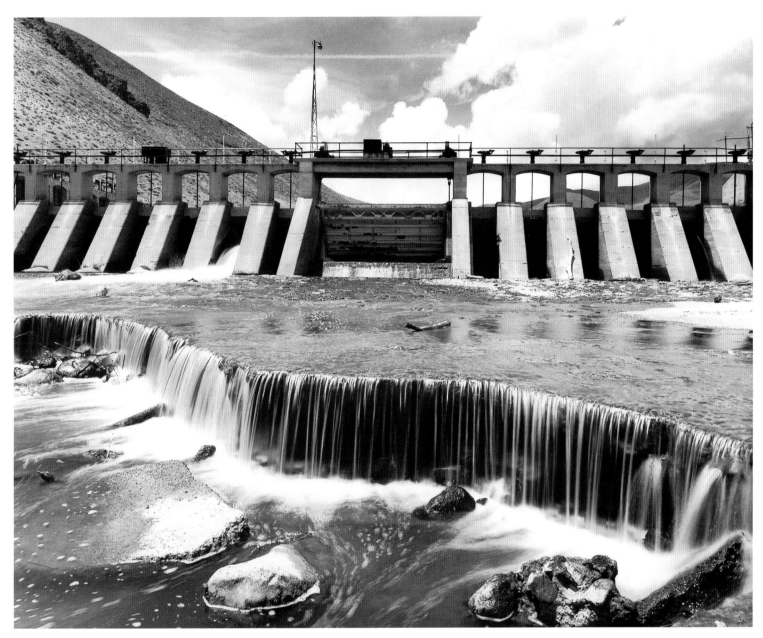

58. Derby Dam, built in 1905, inaugurated arid-land reclamation by transporting water from the Truckee River east of Reno. [rd]

59. Man who lives next to Derby Dam, Truckee River. [rd]

"civilizing" nature by carpeting the desert with green grass. And like others who defend lawns, she blames growth, not a limited water supply: "When we bought this house, there was plenty of water. I am not letting my grass die."

She keeps the desert as far to the edges of their lot as possible. We talked one morning over breakfast, after yet another long, dry summer; by September, Stage 3 (one day per week) watering restrictions were in place, yet I still heard that hiss each morning. The Carson Ridge of the Sierra peeked through the large window near our table, showing stands of aspen beginning to turn gold on the sides of the mountains. We discussed another neighbor's lawn, which was slowly being converted to xeriscape, replacing the lawn with drought-resistant plants and rocks.

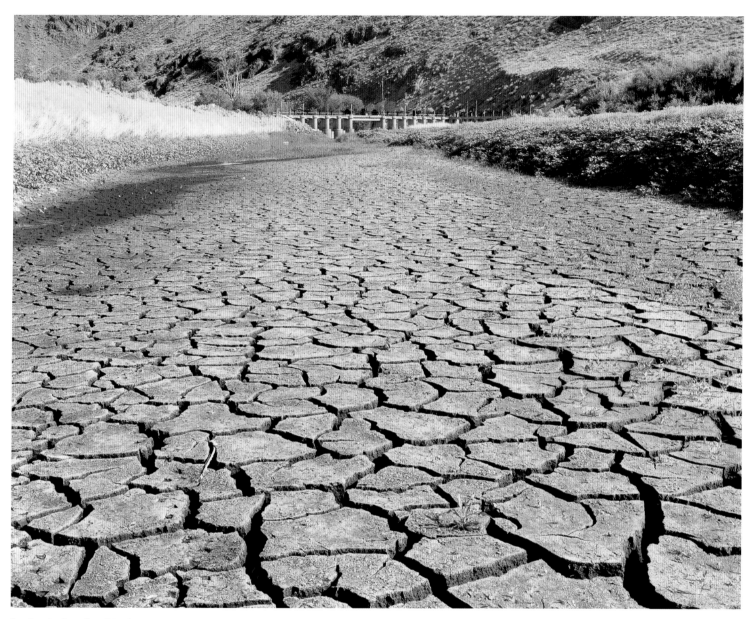

60. Cracked mud and Derby Dam,
Truckee River. [pg]

"It's ugly," she said, referring to the other neighbor's indigenous boulder and sage-brush yard. "And it doesn't go with the houses here. I mean, look around—the reason we bought in this neighborhood was that it looks so quaint, with the trees and lawns and older brick homes," she said, aptly describing the charm of our neighborhood.

I disagreed. "His yard will look great next year. But it *does* take a while for the desert plants to take hold, and from what he has told me, it's expensive to take out the lawn, put

in these native plants, and then hook up the drip system." I silently envied his garden of poppies and lupine that would bloom in later summers.

She continued, "Anyway, I'm not fond of rocks. And besides, why should *we* go to that expense when people keep moving here and using up more water? I plan to sell this house in another year, and that will be tough to do if it looks like a desert."

The words "But it *is* one" fell on deaf ears.

"I think the whole thing is a bunch of crap," she said.

"The drought?" I asked, pancake dangling from my fork.

"No, this watering restriction nonsense. I am not going to let my lawn die if *they* are going to keep letting people from California move in and do here what they have done in L.A."

I paused. "So what you're saying is that it's okay for you to be here, to have a lawn, a garden and so on, but it's not okay for anyone else to come here and do the same?"

"Yeah, exactly. As long as they are still issuing building permits, still letting people come here in droves and not controlling the growth of this place, to hell with it. Why should I suffer so that more people can come here and ruin it for everyone? People want to come here and enjoy the cleaner air without giving up anything," she said.

As we talked, I realized she articulated exactly the view I heard from an old-timer when the drought first began: "Why conserve water when it will just be gobbled up by casinos and developers? Might as well use it till it's gone," he'd said.

She summed up her argument: "Can't you see the contradiction of conservation? *We* conserve water, while doing so makes more water available for new growth. You can call me selfish, but I am not going to espouse some phony desire that others have the same opportunities I have. There're too many of us here already."

What she said illustrated yet another change to the landscape: The Truckee Meadows used to be just that—a meadow, full of riparian habitat, otter, fish, birds. Driving across town offers a strange version of the Jeffersonian dream. Not yeoman farmers, as Jefferson once envisioned, but a tourist-town mix of casino workers, university personnel, and middle managers live amid those manicured swaths of fescue, within those high privacy fences. Reminiscent of pioneer stockades, these quadrants divide residents from each other; but more important, the fences impose on those who live within them a kind of blindness to the world beyond.

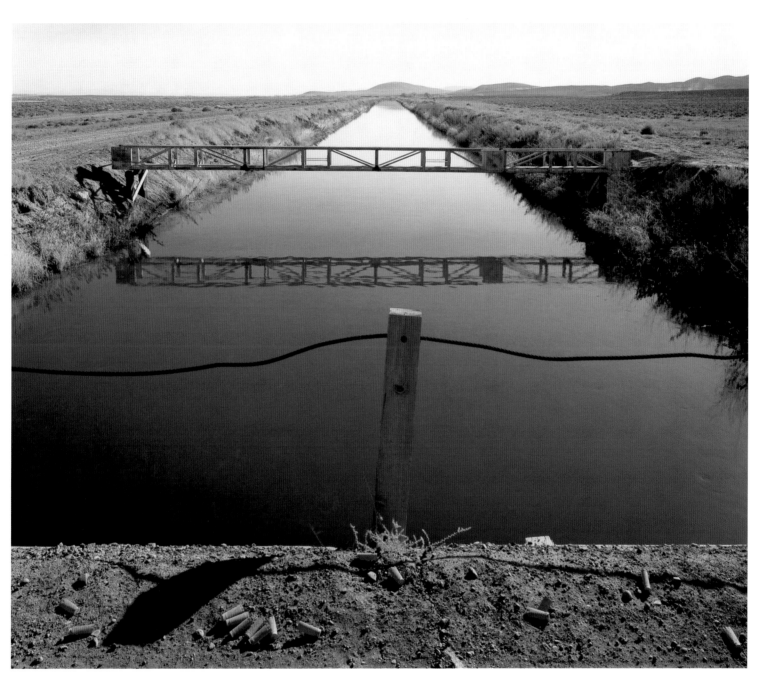

61. Shotgun shell casings and Truckee Canal. [rd]

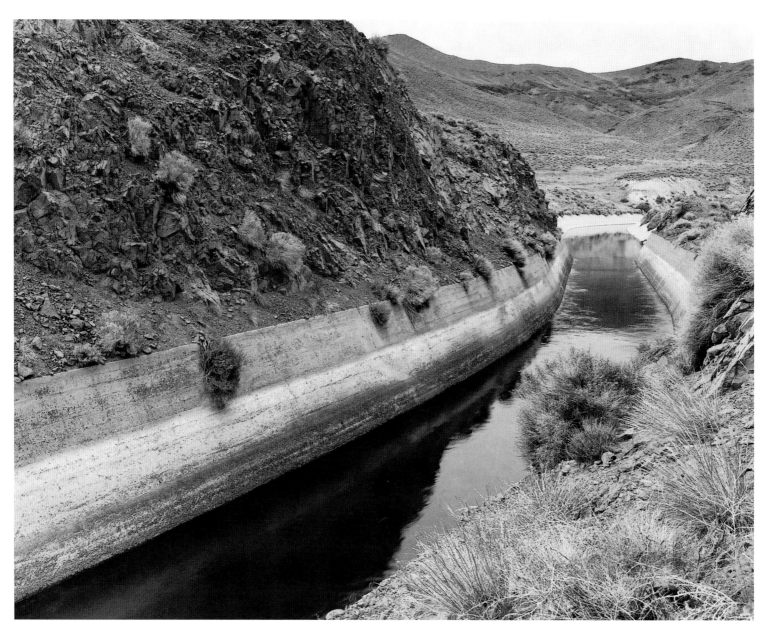

62. Truckee Canal near Hazen. [pg]

63. Human-made bird nest at Clark Power Station along Truckee River east of Reno/Sparks. [pg]

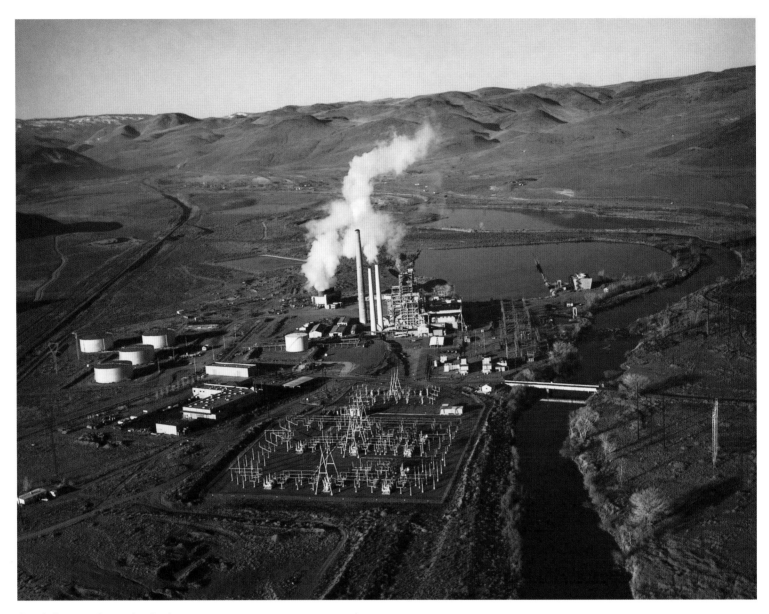

64. Clark Power Generating Station
along the Truckee River. [rd]

A friend from New Mexico, his family descended from pioneers, reminded me that lawns were a way of demonstrating to relatives back east that this uncivilized, wild landscape could in fact be tamed. "Lawns were always kind of a status symbol," he said. "It took a lot of money to get a lawn going in Albuquerque. People from our home, back in Illinois, came out to visit, and you had to show them that you were doing okay in what they saw as a forsaken place. You had to transform the desert to make it habitable."

Lawns demonstrate on a small scale what happens when we import a lifestyle that

65. Truckee River and railroad
bridge east of Reno/Sparks. [pg]

clashes with available natural resources. Our predecessors, whether they came west ten
years or five generations before us, brought with them their taste for lush green lawns and
the belief that land should be tamed and brought under human control.

The new developments spreading into the hills encompassing Reno vary in design
and price, but most will be surrounded by green lawns. All are marked by the small flags,
whipping in the wind, that draw the eye to advertisements; the signs promise not just
houses but entire lifestyles, new beginnings. An advertisement appearing in the *Wall Street
Journal* uses John Muir to sell exclusive real estate. A quotation from Muir tops the ad:
" 'Thousands of tired, nerve-shaken, over-civilized people are beginning to find out that

66. Old McCarran Ranch, on the Truckee River about fifteen miles east of Reno. [rd]

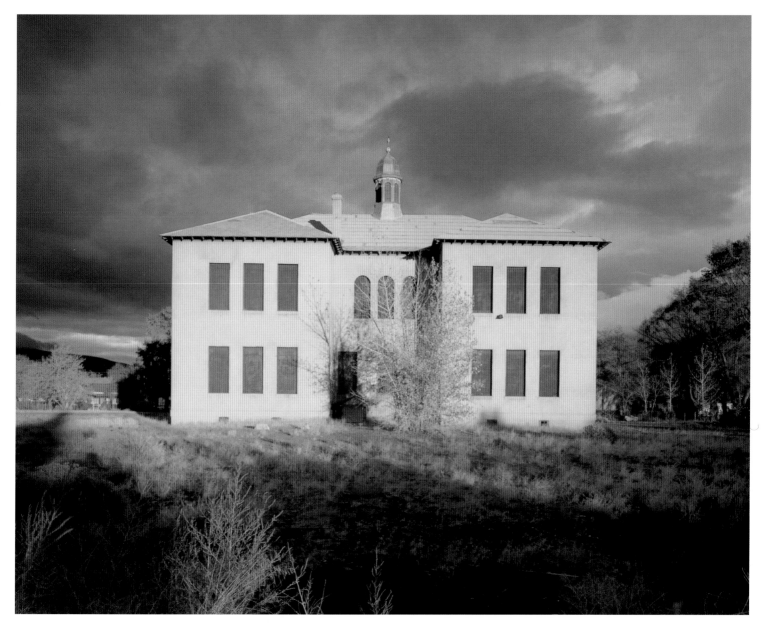

67. Old Natchez School, Wadsworth, Nevada. This school was built by the government to educate Paiute children, who were scorned at the Anglo public school in town. As issues of trespass became more complex, and as more and more Anglo families were taking permanent residence on reservation land, the town of Wadsworth along with about 18,700 other acres of reservation lands were taken out of the reservation boundary. Paiutes were told that they could "remove to this oversized schoolyard [about 110 acres] and there remain under government supervision if they so chose. The school . . . thus bec[ame] a tiny, isolated reservation in and of itself" (Knack and Stewart, *As Long as the River Shall Run*, 196). [rd]

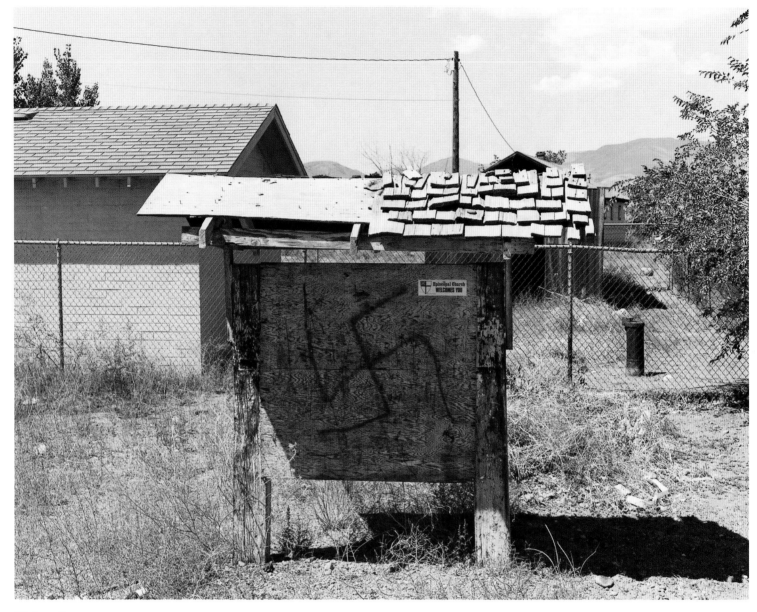

68. Swastika on announcement
board at Wadsworth, Nevada. [pg]

going to the mountains is going home.' Muir knew this a century ago," the ad goes on to
claim. "You know it has never been truer than now. You've moved up the ladder. Now
move up the mountain."

I lived for a time in one of the then-new developments that scored the lower foothills
of Peavine Mountain. Housesitting for friends, I could enjoy their delightful redwood deck
and hot tub in that tiny backyard, without the responsibility of owning and maintaining

69. Beaver skull on wood tripod along Truckee River north of Wadsworth, Pyramid Lake Paiute Reservation. [pg]

them. My evening soaks in the tub allowed me to study the ways in which maximum profit is extracted from the land, by stacking houses upon each other.

Any memory of the sage-covered foothills had been bulldozed and scraped beneath these expensive tract homes with their pastel siding and curved windows. Hearing the spring wind whine on those evenings was something of a sacrilege, for I had walked every ravine and hummock of that very hill, had climbed up to dramatic rock formations each

70. Truckee River north of Wadsworth. [pg]

evening to forget the multitude of sins and responsibilities in my life. I had napped up there between the piles of boulders, interwoven with green lichen and red paintbrush; I checked out the clouds, the spring wildflowers, the silver light of a November afternoon, seemingly high above the brown layer of air on a "green (okay to burn) day." All that has been leveled, replaced with yet another generic tract, carpeted by sod. As the development slopes gently toward the street, the small flags wave, announcing Stone Ridge or Vista Meadows or Juniper Hills. Only in name is there the vaguest recollection of the original terrain.

Suburban sprawl, new or middle-aged, represents more than just growth. It registers our appetite for ready-made community, convenience, and, in an odd way, conformity. Wandering through the new development, we might feel comforted by the familiarity of

71. Home on the Range and Truckee River. [rd]

the same old strip malls, the same state-of-the-art landscaping, a few spindly trees and tatty marigolds. But we feel suddenly dislocated in the midst of these signs of progress, these advanced sprinkler systems and the orderly once-a-week mowings. We could be anywhere—Reno, Phoenix, Walnut Creek; all are contributors to the yearly diversions of western water supplies. The Truckee, the Colorado, the Hetch Hetchy—all compromised to green up these municipal areas.

A friend recently provided another view of development as we spent an afternoon driving a visitor around town, showing him the sights of urban Reno. As our route soon

72. Snow-covered Truckee River and railroad bed, site of first Battle of Pyramid Lake. In this battle, whites suffered a crushing defeat by Paiutes: sixty-two whites were killed by Paiutes who were retaliating for the kidnapping of two young Paiute girls. [rd]

revealed, we were to take our visitor to the "good neighborhoods." We drove south, toward the foothills of the Sierra, where the larger, exclusive homes have been built on luxurious parcels of land. Our visitor whistled appreciatively at the ponds and streams flowing near impressive Tudor-style homes with four- and five-car garages. As we followed the curving, two-laned road through pastureland, a feeling of grace seemed to descend upon the three of us. It was relaxing, driving past these older homes, each with its

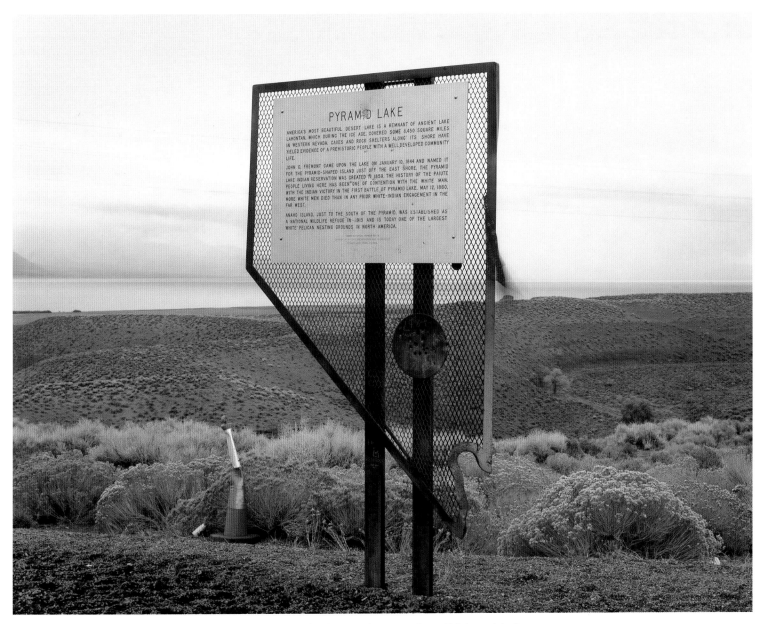

73. Historical marker at Pyramid Lake. The text reads: "Pyramid Lake. America's most beautiful desert lake is a remnant of ancient Lake Lahontan, which during the Ice Age covered some 8,450 square miles of western Nevada. Caves and rock shelters along its shore have yielded evidence of a prehistoric people with a well developed community life.

"John C. Fremont came upon the lake on January 10, 1844 and named it for the pyramid-shaped island just off the east shore. The Pyramid Lake Indian Reservation was created in 1859. The history of the Paiute people living here has been one of contention with the white man. With the Indian victory in the First Battle of Pyramid Lake, May 12, 1860, more white men died than in any prior White-Indian engagement in the Far West.

"Anaho Island, just to the south of the Pyramid, was established as a National Wildlife Refuge in 1913 and is today one of the largest white pelican nesting grounds in North America." [rd]

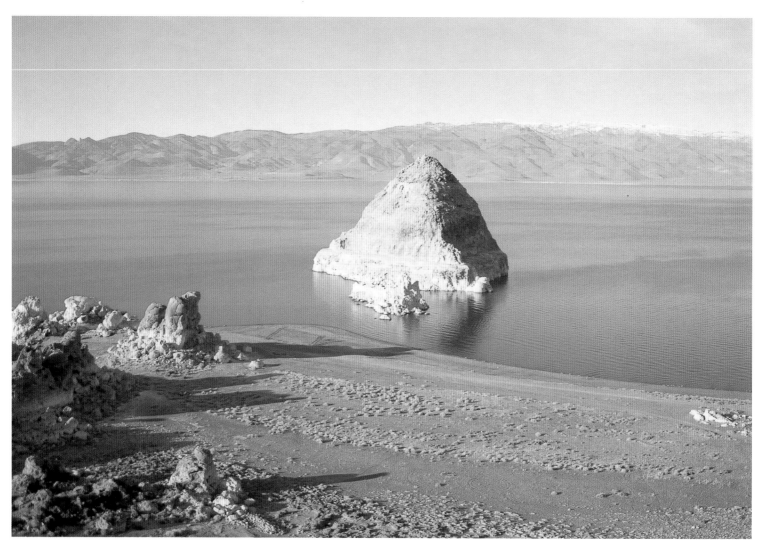

74. The pyramid for which explorer John C. Frémont named Pyramid Lake. [pg]

own private pond populated by a pair or two of Canada geese. A bicyclist whizzed past. "This is nice," our visitor commented.

In a while, our road dead-ended at the southern end of town, where we had to rejoin the busy four-lane traffic on the business route. The feeling of ease disappeared. Traffic and noise increased while the scenery changed. Old trailer parks, run-down motels, and palm readers clung to their original sites along what had formerly been the two-lane highway (old 395), while more contemporary enterprises like Home Depot and industrial parks began to occupy more and more of the highway frontage.

My friend gestured with her hand toward one old brick motel and remarked to our visitor, "See? All of Reno used to look like this." I found her comment interesting in its ambiguity. The nostalgia I felt toward the tacky, unsophisticated metal trailers and the

neon signs evoked a different response in my friend. Where I saw remnants of a bygone era in a classic neon sign, a woman's figure swan-diving into space, announcing "Pool," she saw a past to be forgotten. These seedy indicators of the small town Reno once had been were being erased, replaced by new industry. My friend saw these changes as progress, a definite improvement over the original.

One of the newer complexes in the south part of Reno houses the Sierra Pacific Power Company, which sells electrical service, natural gas, and water. Sierra Pacific is a major player in dividing the Truckee River, as the company not only delivers the water but also controls storage and treatment of the area's water supply. Visitors admire the landcaping and curving driveways that lead to modern brick and glass structures. The whole area bespeaks order, engineering, an oasis of civilization in the desert, surrounded as it is by grass, trees, and plentiful examples of xeriscape. I sometimes pay my bill in person there just to experience the serene drive through their compound, where I frequently spot employees jogging along the fitness trails. Equally impressive are the flyers that accompany monthly bills from the power company that inform customers about what measures are being taken to "bank" water for the continuing drought.

An interesting note: The bills I pay each month contain metered amounts for electricity and natural gas. The water portion of the bill is calculated on a flat rate of forty-nine dollars a month. This amount will not vary, no matter how much water I use, no matter how much or how little I comply with the recommended Stage 3 (water only once a week) regulations. To some minds, forty-nine dollars is plenty to pay for water; yet I can never avoid the comparison with what the water cost in Arizona in the early 1980s. There, a one-hundred-square-foot patch of lawn cost me, in summer months, about eighty dollars per month to water.

From the point of view of Janet Carson, Sierra Pacific's water resources manager, "we have adequate water for eight or nine months during the year, and drought storage provides water the rest of the year." She said that Sierra Pacific owns water rights totaling 22,250 acre-feet in two upstream reservoirs. An acre-foot of water is the amount of water it takes to cover an acre one foot deep, or 325,851 gallons. That water is skimmed from reservoirs during the hottest summer months, when the Truckee runs dry. A *water right* is a legal term for who may use Truckee River water. As developers buy land from farmers, they must also purchase water rights in order to develop the property. Thus, land that once required water only six months out of the year now receives water all twelve months to support homes and businesses.

Above all this discussion hangs a cloud of controversy over water meters. Currently, only new construction requires them, but the issue of retrofitting the older homes is a constant source of debate. Local sentiment toward water meters borders on emotional,

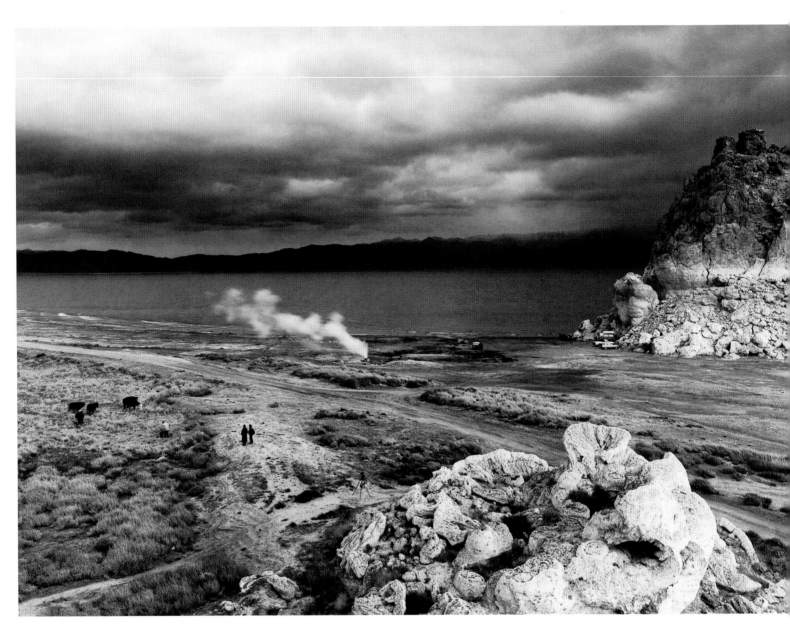

75, 76. The Needles at the north end of Pyramid Lake. Closed in 1997 to nontribal members, the Needles was a popular recreation spot until degraded conditions caused it to be closed. [rd]

Carson told me, especially among those who have been in Reno all their lives. Their position is well known—so strong is the desire for green backyards, and so convinced are residents that conserving will only help developers, that homeowners often do not conserve. Despite the continued threat of drought, as well as efforts by Sierra Pacific to penalize wasters, many locals tend to water as they please.

During a discussion that morning about the municipal need for more water, I learned about Janet Carson's background as a professional engineer and avid outdoor enthusiast. Slender and athletic, she told me how living in Reno appealed to her because of the access

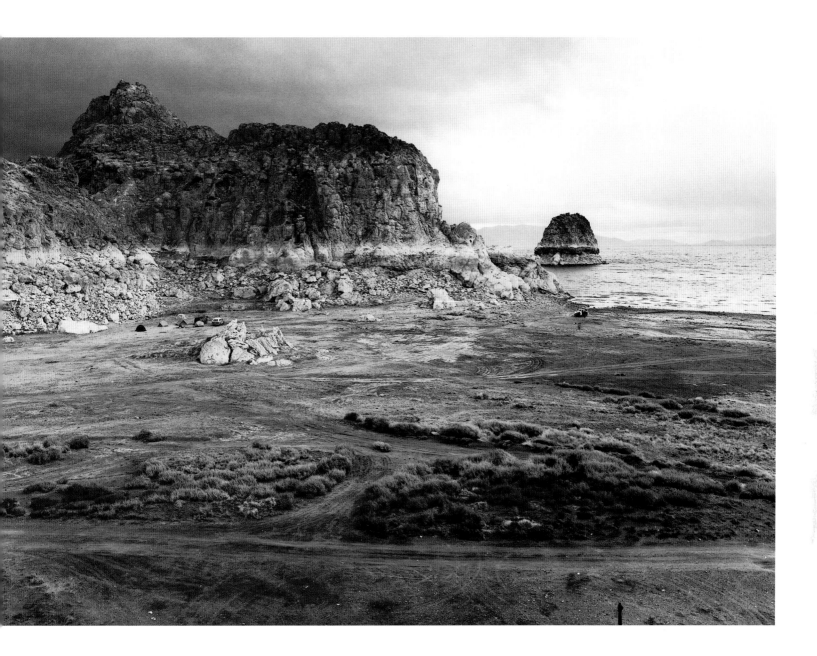

to outdoor recreation, especially hiking and alpine skiing. Her perspective on water use, as both long-range planner and spokesperson for the company, is, in her word, "neutral." The word *neutral* came up several times in the context of discussing the conflicts, the many demands on the Truckee River. Her, like the water company's, position on the drought was fairly straightforward—the utility has an obligation to provide water. Her job is to plan for that, both long and short range, she said, referring to the short range as "coping with the drought." She provided me with statistics showing that though dry summers will

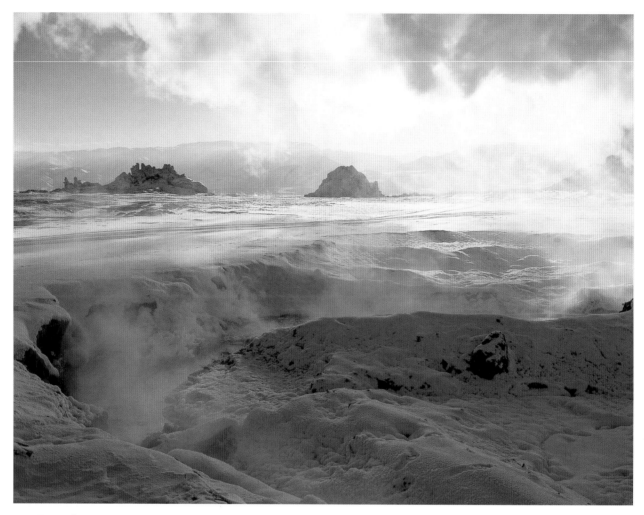

77. Hot springs at the Needles, Pyramid Lake. [pg]

deplete the water table in the area, the winters normally replenish that supply; lately, though, the levels are not rebounding as quickly.

Perhaps the most interesting thing about chatting with Janet Carson was learning how she dealt with the requirement that she spend hours each day answering skeptics like me about the water situation in the Truckee Meadows. Her words were clear and unconflicted about the rapid growth in the area and what its implications might be for water usage. "We can buy as much water as we need," she said, referencing charts and maps that showed water stored in reservoirs upstream that is available for "borrowing purposes." This water, slated for Pyramid Lake fish, can be used and paid back in the following year. The image of reservoirs drawn down to their bottoms, of fish being transported away from empty ponds, was becoming a familiar one.

A recent flyer accompanying my monthly bill states, "Local hotels and casinos now

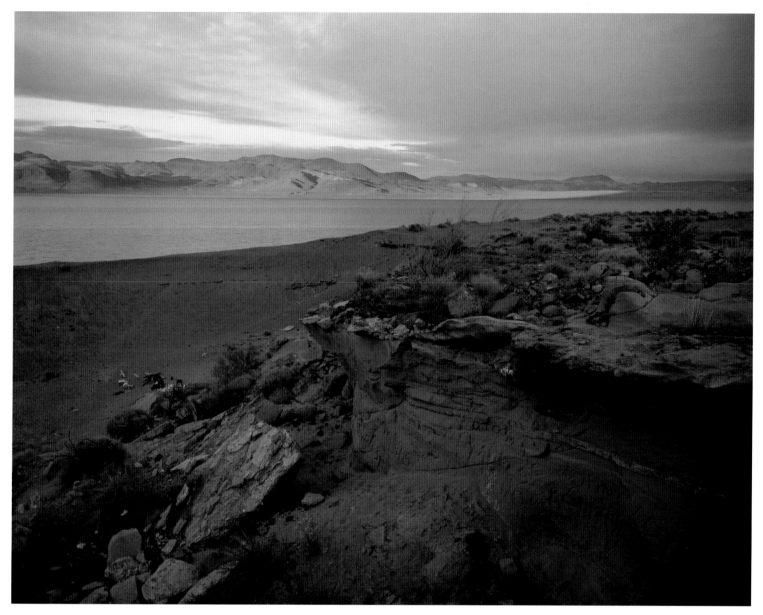

78. Modern petroglyphs, fire, and sunset at Pyramid Lake. [pg]

use less than 10 percent of our area's water thanks to metering and increased conservation measures. And developers must provide enough water rights for everything they build— real water that we can store and use even in the driest years. *The bottom line is, you don't have to worry about water*" (emphasis theirs).

My friend Amanda has never driven a car. Unlike other women in their sixties, Amanda walks nearly everywhere she needs to go, or takes the bus. We met one day walking along the Truckee River, though neither of us was really there for the sort of recreational walking

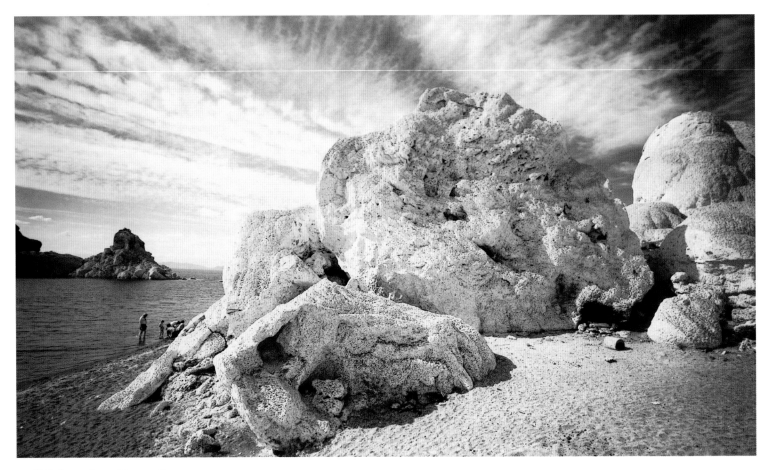

79. Tufa formation with spreading
clouds, Pyramid Lake. [rd]

that we saw others doing. We met as the waters of the Truckee were disappearing in the summer of 1992. We stood at the Lake Street Bridge, the one made famous in Marilyn Monroe's last movie, *The Misfits*, the bridge from which Monroe's character throws her wedding band into the Truckee River. Unlike Monroe, we were there, Amanda and I, not to forget husbands but to check out the disappearing Truckee. Our common interest in the river and its slow demise had brought each of us to that bridge several times that summer, and those visits sparked our first conversation.

"I always liked the view from here," she said, looking west toward the crest of the Sierra, which peeked above the buildings and trees. "You used to be able to picture the water flowing from the Sierra. Not today though."

I asked how long she had lived in Reno and got a brief history. She told me what it had been like in 1954 to come to Reno as a young widow, her husband killed in a mining accident. Born in Pioche, in eastern Nevada, she had moved to Reno for anonymity, for solace in a place where she knew no one. "I didn't want to stay in Pioche. I wanted to start

80. Fork in a desert road near
Pyramid Lake. [rd]

over, get work in a town where everyone wasn't watching to see what your next move
was." At twenty-four, she began working in clubs downtown, dealing blackjack.

She sat on one of the low concrete walls that line the edge of the riverwalk to light a
cigarette, and I noticed how strong Amanda looked, despite all the years of smoking, all
the years of working graveyard shift in the clubs. As we talked, I registered her dark
sunglasses and very black hair, piled in what we used to call a beehive; a thin scarf held it
in place. When I looked at her, I saw images of a hundred other women, who, like her,

81. Lone tree, looking north, near Pyramid Lake. [rd]

came here for the independence afforded by casino work. She was drawn to Reno because of its location, its small-town isolation set next to the Sierra in a high desert valley. "It was a friendlier town then," she recalled. Her sunglasses pointed toward a pair of ragged men—homeless people who lived along the river. "We never had people living this way—a church or somebody would have gotten money or food together for those who had fallen on hard times. There are so many now."

82. Tufa structure near the Pyramid,
Pyramid Lake. [pg]

As she spoke, one of the men ambled toward us. I automatically stiffened. She looked up at him and said softly, "Hello, Bruce."

He looked at me and then addressed her. "Do you have a spare cigarette?" She must have anticipated his request, because she was already shaking the cigarette into his hand. He might have been fifty. He was a big man, tall and barrel-chested. His grey hair and tanned face gave him an oddly prosperous look, as though he belonged out on the golf

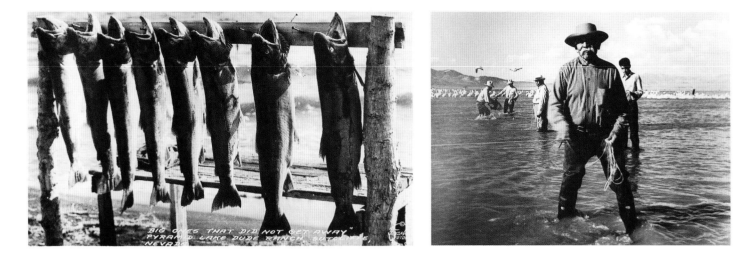

course. I looked down, avoiding his eyes, and saw his shoes: they were old faded Keds, the rubber rotting away as each big toe poked through. He thanked her and drifted away.

I asked her if she felt safe, walking along the river. She turned to me and said, "I know most of them. They don't bother me. I help out with a dollar or two when I can."

Who had helped her, I wondered? She described those early days, learning to deal blackjack while living at a women's guesthouse. I knew such places had existed; you can still see some of them around town, boardinghouse arrangements where women would wait the six weeks required by the State of Nevada until they could file for divorce. At the guesthouse, Amanda felt out of place. "It was kind of queer," she said. "These women from New York or Chicago were there, all waiting to get rid of a husband. And I had just lost mine before I even knew him. We had a hard time making sense of one another."

She didn't fit in with either the divorcées or her customers at the blackjack table. She insulated herself from the world by drinking a bit. Not that she is an alcoholic, she said, but in the old days, coming off shift at seven or eight in the morning, it was hard to go home to that empty room. There was a certain warmth she would feel from a bloody mary, poured in a plastic tumbler in her room, with the last evening's paper spread in front of her. She'd laugh out loud at the "Li'l Abner" comics in the *Reno Evening Gazette.* She'd make lists of things on sale, things she needed to buy: nylon slips at Montgomery Wards, a radio for listening to the news.

The Christmas ads depressed her. "See Santa tonight 6:30–8:30," the stores advertised. "I couldn't stand seeing all that holiday joy, all those people thinking they had life figured out, when I knew how easily it could turn sad."

Those winter afternoons came alive for a moment, even as the August sun beat down on us. It was easy to picture her somber room, shadowed at four or so in the afternoon, the

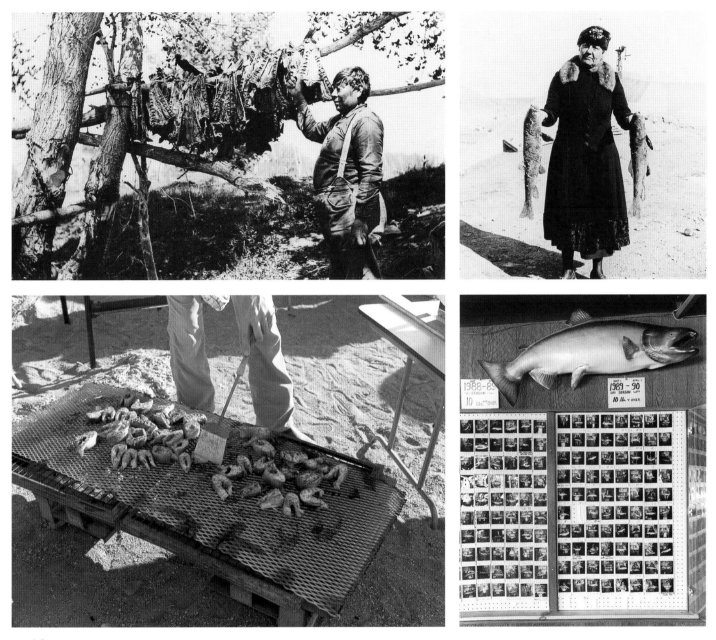

(top left)

85. Paiute man and drying fish. Courtesy Special Collections, University of Nevada, Reno, Library.

(top right)

86. Holding the day's catch. Courtesy Special Collections, University of Nevada, Reno, Library.

(bottom left)

87. Barbecue of Lahontan cutthroat trout at Warrior Point, Pyramid Lake. [pg]

(bottom right)

88. Trophy fish and photographs of fishermen, Crosby's Lodge at Pyramid Lake, Sutcliffe. [rd]

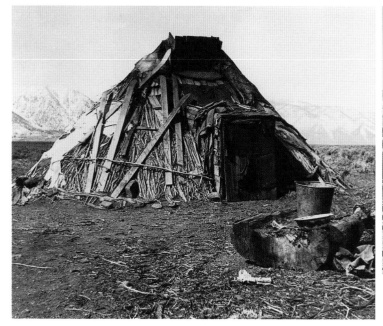

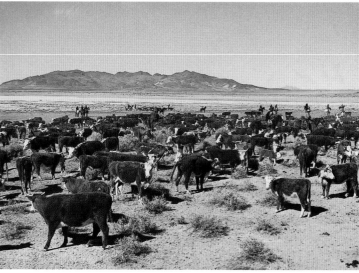

(left)
89. Aboriginal housing near Pyramid Lake. Courtesy Special Collections, University of Nevada, Reno, Library.

(right)
90. Indian cattle herd that includes sixty-three different brands. Pyramid Lake Paiute Reservation, Nevada, 1940. Photographer Arthur Rothstein. Courtesy Library of Congress, Prints and Photographs Division, FSA/OWI Collection [reproduction number LC-USF34–24021-D].

thin December sunlight quickly disappearing behind the crest of the Sierra to the west, the sparrows outside her window frantically announcing the dusk. What must it have felt like, I wondered, to be so alone in a small town? I recalled my own experience of moving to Reno, when I quickly realized that the friendly western stereotype of the small town was a myth, at least in my immediate experience of settling into a new neighborhood and job. As an outsider, I was politely ignored until I blended in with the established landscape of other transplanted species.

Amanda's hands, dealer's hands with their perfectly shaped oval fingernails, moved with the fluidity and grace of swans as they reached into her bag to find the vinyl cigarette case with its slender lighter attached. Her gestures, like her words, recalled for me so many other women like her, who had left a somewhere-else to escape reminders of loss. Working as a dealer gave her an identity, a sense of some economic self-reliance. Her black-and-white uniform protected her, made her seem exotic and untouchable. She recalled for me how she grew tired of her customers' small talk, the kind that inevitably passed between herself and those at her table. They would ask where she was from (no one had ever heard of Pioche, Nevada), or where the bettors might find some good sightseeing.

"I'd recommend places I'd visited out by Pyramid Lake—the Needles or the tree-lined Truckee River banks—and those men—they were always men—would just argue with me, saying 'Hell, nothin's out there but a few Indians.' And, oh, they got annoyed! Their wives would be standing there, nervous—afraid of *what*, I didn't know—those men never flirted

with *me*—they thought I was downright odd. But the wives would get all agitated—'come on, now, let's get going.' I had to make some real changes in my public-relations skills," she said with a laugh. "Otherwise, I'd never have made a damn dollar tip."

Although Amanda had since retired, she didn't forget that long-ago dark time when her grief sent her in search of isolation. She found peace in such isolation, turning down opportunities to move to other cities—to Elko, where her sister taught school; to Las Vegas, where she would have been closer to her mother. There was something, she said, that drew her back to the Truckee River, to the relative freedom of this Great Basin small town. "Relative, I guess, meaning there were a variety of choices open to me here in Reno," she explained. "I was getting up in my twenties; I had no interest in marrying again; and in those days, women were under much greater pressure to settle down. I knew I could take care of myself here and stay employed."

She told me that life had been better for her since retirement. She got out more, she said, and laughed behind her sunglasses at my quizzical look.

"Where do you go," I asked her, "with no car?"

She had a friend who took her on desert trips, to hunt birds and look for rocks, out there in the "boonies," as she called it. "*That's* why I have stayed here," she continued. "Because of this river and the tree-covered ridges. Even then, when I first lost my husband, nothing comforted me like the quiet I could find in those open places. And seasons," she said. "You could hypnotize yourself under a canopy of golden October cottonwoods." We sat, imagining the colors of autumn, listening for the rush of the water in the shade of the drought-stricken trees, but hearing only the chatter of sparrows, smelling the skunky river smells emanating from willow and tamarisk and muddy pools among the rocks.

She paused and looked at the river. "Reno is a big city now, and this drought makes it more obvious than ever. It's like we've taken out all the life, sucked the river dry. But there have been floods, too. I have seen entire living-room sets floating down this river during a flood."

It was hard to imagine, dry as the river was that day in August of the sixth drought year. We walked west along the river, following the path where she had walked for forty years. She told me of one flood, in December 1955. That fall had brought a long Indian summer, and then the warm, dry days of late autumn changed in one night to winter as the first storm arrived. She had left her apartment with only a light jacket at eleven o'clock one November evening, and during the night, the wind began to howl with the approach of the front. By the time her shift ended at seven the next morning, ten inches of thick, wet snow had fallen. The storm had taken everyone by surprise.

Storm clouds cloaked the Sierra for weeks that winter, depositing a snowpack twelve feet thick at elevations above 9,000 feet, even before Thanksgiving. People joked about the

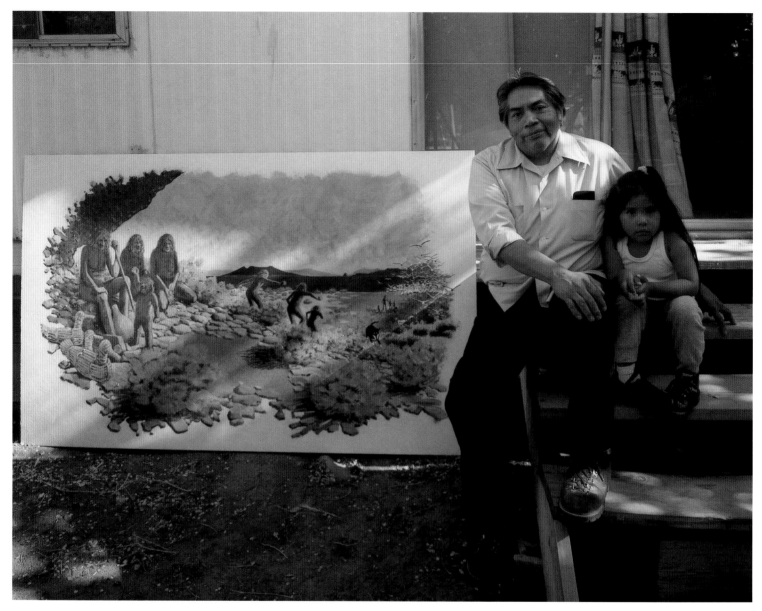

91. Washoe/Paiute artist Clayton Sampson and granddaughter with his painting at the Reno-Sparks Indian Colony, Reno. [rd]

winter of 1846, the year of the Donner Party tragedy, when emigrants had been caught by early snows, many of them perishing, except for those who resorted to cannibalism. She thought about that winter and the Donner Party, walking home in the wet, cold Thanksgiving morning. The wind whipped the snow horizontally into her face, and her boots slipped in the finely packed powder covering the street. The tourists reminded her of the Donners and the Reeds—willing to risk a shortcut, never knowing what kind of weather might trap them.

December continued to bring unsettled weather, mostly light snow to the valley, until just before Christmas, when the winter storm track moved south and began to pull moist, warm air from the Gulf of California over the Sierra Nevada. The combination of the season's heavy, fresh snowpack and the sudden warm rain set the stage for the flooding that occurred two days before Christmas in 1955.

"The water downtown was over four feet deep. I couldn't get to work; the phones were out. It was pretty bad on Christmas Eve. But no one stopped gambling—there were stories of customers standing around the Mapes, playing slot machines in hip boots."

I hear my dog lapping water out of his bowl next to my back door. Summer's intense desert heat fags him by 10:00 or 11:00 each day. He retreats to the shade; I go swimming. Water again: Pools of it glimmer, miragelike, aqua mirrors nestled among tall trees.

What luxury, to swim in the desert heat, cool off, refresh. My swimming has taken me to many pools in the area, but my favorite is the outdoor pool at Idlewild Park, located near downtown and the Truckee River. The marvels of engineering have provided an Olympic-sized pool within spitting distance of the drought-impaired river. When I swim there, at 5:30 or so on a July evening, I am doubly impressed by this water in the desert. The fifty-meter pool shimmers in its surrounding rectangle of cement; above it, the mature cotton-woods and elms wave in the late afternoon wind. Sometimes a thunderstorm approaches, sending leaves and debris swirling toward the pool as we swimmers fight the tiny waves the wind kicks up. Even as one arm extends briefly from the water in crawl or backstroke, it dries instantly in the desert heat. What pleasure to be blinded momentarily by that July sun as it sinks lower, burning relentlessly in my face as I float on my back, taking in the green of the leaves against the blue sky.

The pool at Idlewild Park was built in the 1930s, with money raised by federal grants and a bond issue. An interesting story surrounds the building of the pool in Idlewild Park. An August 1934 *Reno Evening Gazette* article recounts the near-drowning of a young girl who "fell into the Truckee river [sic] at Wingfield park [sic], and became wedged in the fish ladder near the dam." The six-year-old had waded into the river to cool off when her legs were swept out from under her by a strong undertow, and she was pulled downstream to the dam. One leg lodged in snags, trapping the child under water until her mother's "quick work" saved her. Her mother and several bystanders succeeded in extricating her from the river. At this point, she "appeared to have succumbed, but after the rescue squad worked over her for some time . . . she finally regained consciousness."[13]

When she told me this story, my friend Vera had just finished her mile swim in Idlewild Pool. She recalled that the near-tragedy had been written up in the papers: "They mis-

spelled my name," she said, "and I remember being very indignant." The next year, a bond issue passed to fund the building of Idlewild swimming pool.

Vera, now in her seventies, swims here unafraid. She never did develop a fear of the water. She says she has been lucky: "Some people never get over something like that. I don't really remember what happened, exactly, except that afterwards, they took me to Saint Mary's Hospital, where the nuns painted my fingernails with Mercurochrome to show me it wouldn't hurt."

Our after-swimming chats deepen our friendship and provide me with another vantage point on the issue of growth in the area. I am fascinated by Vera's descriptions of how different life was here fifty years ago. There was no Interstate 80 crossing the mountains into California. The trip to Berkeley, California, where Vera completed her baccalaureate degree, took most of a day on the old U.S. Highway 40, as opposed to the three-hour jaunt now afforded by modern transportation and the interstate highway. Until the 1960s, when the Olympics at Squaw Valley heralded the completion of the interstate highway, Reno was indeed insulated and isolated from the world. The Sierra, she tells me, were always visible in the crystal-clear desert air. And no one worried about water. "Now, we lack a sense of balance—there are just too many of us. We outstripped our resources about twenty years ago, in my estimation," she said.

I grimace in agreement and guiltily promise to leave; after all, I am part of the problem. We discussed how easy it is to look at recent arrivals as the source of the problem. "Those Californians and their money," I joke exasperatedly with Vera. But in truth, these comments mirror some of the local sentiment of wanting to blame "outsiders" for the scarcity of resources in the changing West.

Our responses to newcomers, in the West or the neighborhood, demonstrate how easily our perspectives shift toward who the "true" westerners (or Americans or any other number of groups) are. As *High Country News* writer Tom Power points out, "It has become commonplace to attack and ridicule the socio-economic changes that are taking place in the Rocky Mountain West. With disgust and caustic humor residents lash out at the new 'cappucino cowboys,' the brightly colored, lycra-clad mountain bikers, the 20-acre ranchettes, the trophy homes of newcomers, and the network surfers on the information highway."[14] Power's essay continues: "These disgusting newcomers are contrasted with the upright and dignified ranchers, farmers, loggers and miners of the past . . . [who are] seen as the true lifeblood of the real West and the interlopers as a disease that is undermining all that was unique about the West."[15]

Power charts the long history of newcomers' values appalling natives, starting with the indigenous people and the wave of explorers, trappers, and miners who overwhelmed each succession of tribes. And his point is well taken when he asks why we are making

such distinctions based on whose line of work is the most moral. Yet Power seems to commit the same sort of "othering" that his essay decries when he advances the argument that although some of us no longer work with the earth (as in mining, ranching, or logging), we are no less connected to it. By referring to ranchers and loggers as those who "work the land to manipulate nature" and whose work involves "the commercial exploitation of the earth," Power invokes yet another "us versus them" position.

When I read this essay, I was struck by how easily we place ourselves in opposition to each other, instead of seeing where we come together. Power eloquently describes one group of westerners criticizing another, then proceeds to do the same thing. Our unconscious actions toward each other and the land continually throw us off balance, even when we claim to have the same goals.

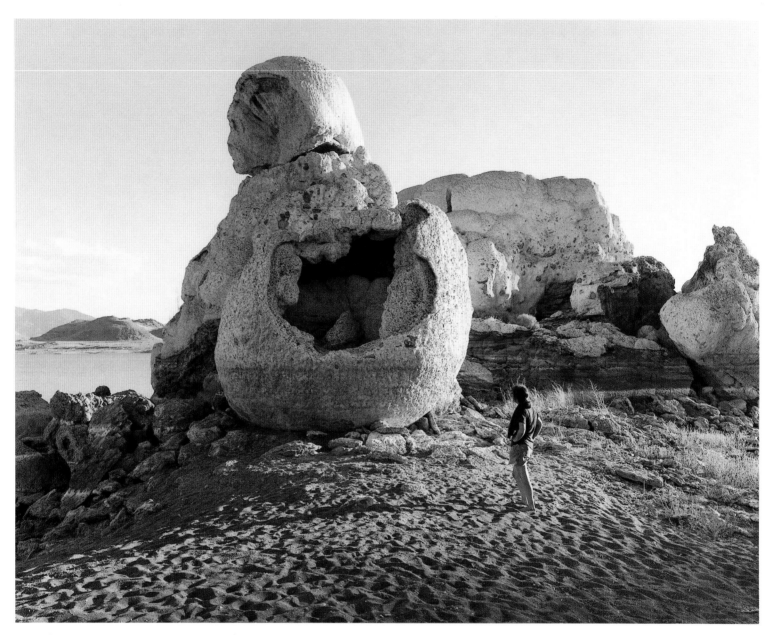

92. Tufa rock at Pyramid Lake called the Stone Mother. This Paiute creation story describes the formation of Pyramid Lake: "The First Mother and the First Father originally lived in the area now occupied by Pyramid Lake, and there raised a family. The sons became heads of the Tribes and eventually began to war with one another. When the Father could no longer tolerate the fighting, he sent the sons away. The Mother, overcome by her sadness at the loss of her sons, knelt with her basket while gathering food, and could not get up. As she wept, her tears filled the valley and created what we now know as Pyramid Lake. In time, she was turned to stone, but the Lake her tears created continues to fill the valley. The Tribes believe that as long as the Great Stone Mother guards the Lake, its waters will continue, and her children will have a home near its shores under her protection" (adapted from Joe Ely, former tribal chairman). [rd]

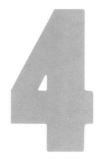

Desert Stories The Lower Truckee River

None other than this long brown land

lays such a hold on the affections.

The rainbow hills, the tender bluish

mists, the luminous radiance of the

spring, have the lotus charm.

—Mary Austin,

The Land of Little Rain

Water in the Truckee River cuts a deep channel as it flows out of Sparks and east toward its formerly ultimate destination, Pyramid Lake. East of the canyons, the river once again flattens as it approaches Derby Dam. There, the Truckee River is diverted via the Truckee Canal to supply water to the Newlands Project farmland in the Lahontan Valley. Beyond Derby Dam, the Truckee River continues its wide meander toward Pyramid Lake and makes a big bend that was once an ideal camping spot for Indians as well as early emigrants. Lush grasses and cottonwood trees line this wide riverbank; desert travelers would flock into the water to refresh themselves and their animals after the arduous desert crossing. These westbound travelers would rest at the Big Bend until recovered enough to continue their journey. From the Big Bend, they followed the Truckee River into the Meadows or took the southern route along the Carson River, heading westward into the mountains.

The Big Bend was also a popular place for the emigrants to ford their wagons; not surprisingly, this "Big Bend Camp" became known as the Lower Crossing and soon developed into a trading post. The town that grew up there was named Wadsworth, for a general who died fighting for the North in the Civil War. Wadsworth would become a major railroad division point.

As the flow of emigrants increased in the nineteenth century, the land between the Lower Crossing and Pyramid Lake came into dispute. White settlers had claimed land that was supposed to be included in the newly established Pyramid Lake Paiute Reservation. Whites began to graze cattle and established mining claims. After a particularly severe winter in 1859–1860, Indians were reported to be starving and freezing to death, according to a *Territorial Enterprise* article that describes the grim situation:

The Indians in Truckee Meadows are freezing and starving to death by scores. In one cabin the Governor found three children dead and dying. The whites are doing all they can to alleviate the miseries of the poor Washoes. They have sent out and built fires for them, and offered them bread and other provisions. But in many instances the starv-

ing Indians refuse to eat, fearing that the food is poisoned. They attribute the severity of the winter to the whites. . . . The Truckee River is frozen over hard enough to bear up loaded teams.[1]

The Pyramid Lake Indian Wars of 1860 resulted from the enormous sense of injustice that Paiutes felt toward white settlers. That, and the combined fear and hostility held by white settlers toward Paiutes climaxed the taking of Paiute land by whites. The unfortunate combination of starvation, anger, and increased evidence of white encroachment on Indian land led to antagonism and rising racial tensions between Paiutes and whites. The Pyramid Lake Wars presented an unsurprising culmination of tensions that continued to simmer throughout the next six years.[2] Although several different incidents are reported to have provoked the battles (from overtly racist paranoia of whites to the murder of five white men, who were purported to have kidnapped two young Indian girls), white military aggression over the next six years finally brought an end to Paiute resistance. Further violence occurred in the last part of the nineteenth century:

> Conflicts between Northern Paiutes and whites were continuous throughout the second half of the nineteenth century. While the only large-scale confrontations were during the so-called Pyramid Lake War, many more Indians actually died in isolated attacks on Indian camps or individuals by organized paramilitary forces and by unauthorized white citizens. The major cause of this violence was the whites' desire to control land and its products, and the Indians' inability to yield to those demands without starving to death.[3]

In the 1860s, the Lower Crossing area began to fill with white settlers who "went about their business without much concern for who owned what and why."[4] Complicating this was the exclusion of the Wadsworth area from the Pyramid Lake Paiute Reservation. Whites interested in availing themselves of the arable land on the Truckee River banks homesteaded the land despite its unclear title. By the time the railroad arrived in 1869 to serve the booming Comstock, Wadsworth was "the most important railroad town in the State."[5] Wadsworth was strategically located not only for the railroad but also for the ranchers who could use nearby Truckee water for irrigation.

In this century, growing up white in Wadsworth presented numerous irreconcilable conflicts. White families, many of them Italian immigrants, had settled on what was called unimproved desert land. The Italians knew about dry climates and irrigation; they cleared the land, dug irrigation ditches, and planted row crops and fruit trees. Their abundant harvests would astonish buyers from as far away as San Francisco—melons, rhubarb, strawberries, and eggplants grew to enormous sizes, and area orchards pro-

(left)
93. Katie and Gordon Frazier, Warrior Point, Pyramid Lake. Katie Frazier was a member of the Pyramid Lake Paiute Tribe, born circa 1890, and died in 1991 at the age of 101. [pg]

(right)
94. Drummer leaving at the end of the day, Warrior Point, Pyramid Lake. [pg]

duced peaches, apricots, plums, and cherries. Other ranchers ran dairy cattle and grew hay. Paiute residents, who lived as tenants on what should have been reservation land, had descended from an entirely different cultural milieu. They were not farmers but had traditionally lived off the desert's resources, hunting and gathering plants, moving from one region to another more productive whenever weather or the harvest season dictated.

The tensions between whites and Paiutes in Wadsworth have not entirely disappeared. Some look upon the successes of Paiute ranchers with thinly veiled envy. One ranch hand I spoke with pointed to a thriving outfit across the river from where we stood and said how unfair it was that Paiutes "didn't have to work," while white ranchers did. He recalled early-morning trips to the post office back in the early 1950s: "There were all these drunk Indians, waiting for the post office to open. We would go to get our mail and the Indian men were barely standing, hassling the post office employees to hurry up and get them their checks, so that they could go out and spend it on booze."

A friend from the University of Nevada recalls another view of Wadsworth and her early life there. "My father worked there, for the government, so we weren't a ranching family. But Wadsworth, its landscape of the desert and the river, are both firmly etched into my childhood memories. My sister and I played on the railroad tracks and the bridge that crossed the Truckee. We would spend hours on that bridge, which was built in 1907,

95. A panoramic view of Pyramid Lake. Some of the Paiute chiefs shown in the superimposition are now residents of Nixon, a town on the southeast shore of the lake. Courtesy Nevada Historical Society.

climbing and then throwing stones into the river from up on our perch. And of course we played along the banks of the Truckee. We dug up old coins and opium bottles that had been buried by the Chinese workers back in the 1860s, when they came to Wadsworth to build the Central Pacific railroad. We played games with these, pretending we were rich ladies who had maps to find more of these treasures. Sometimes we would just wade in the cold springs along the banks of the river—it got hot in that desert in summer and we could go there to cool off, find wild asparagus growing, fish for crayfish or trout, ride horses. The Wadsworth of my memory was in many ways a child's paradise, with those huge cottonwoods that grew along the banks, many of them hundreds of years old.

"We really didn't fit in with anyone—the ranching families didn't befriend us, and the Paiutes didn't want much to do with us either. My sister and I made friends with a strange woman who had come to Wadsworth, ironically enough, with her husband who was writing an article on the guest ranches around Pyramid Lake. These were places where

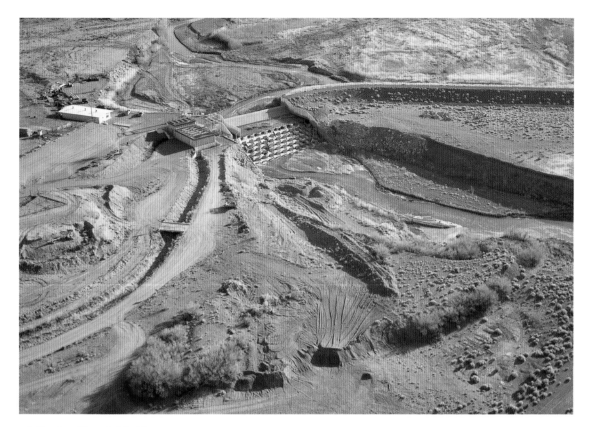

96. Truckee River fish ladder at Pyramid Lake Paiute Reservation near Nixon. [pg]

women could wait out their divorces back in the forties and fifties. I say *ironically* because while traveling with her husband, she fell in love with the desert, and wound up staying there in Wadsworth and divorcing *him*.

"To our eyes, she was quite scandalous. She sunbathed in the nude and wore negligees. But she wrote and was very well-educated. She seemed to know many of the stories about Pyramid Lake, and when we were older, she drove us out to the lake for moonlight barbecues. She smoked cigarettes as she drove; it was like being in a movie, driving on the winding highway along the river under the full moon, feeling the heat of the road. She told us stories about the lake, things she'd heard from her Indian boyfriends, as we grilled our hot dogs.

"Of course, no one would associate with her—neither the ranch women nor the Paiutes. In fact, their mutual distrust of her at least provided one way for them to come together. At one point, the townfolk talked of getting her evicted from the trailer she rented; they didn't like the example she was setting, doing as she pleased. For a while she would live with one man, and then he would go. Then another one would move in. We had a joke that things still went in and out of Wadsworth, even after the railroad had moved to Sparks."

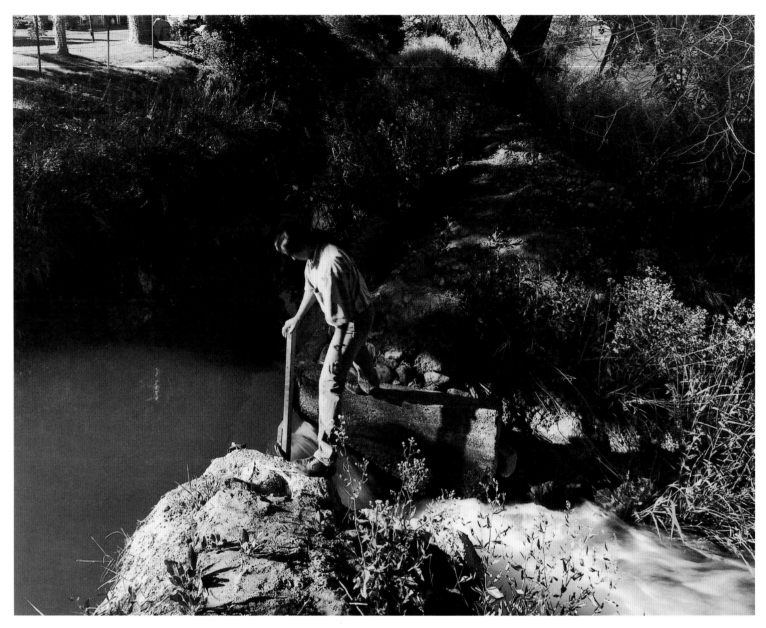

97. Former Paiute tribal chairman
Mervin Wright Jr. at Proctor Ditch,
the first ditch set up under the 1913–
1944 litigation that apportions the
Truckee River water, known as the
Orr Ditch Decree, near Wadsworth.
[rd]

Ranching Stories The Lahontan Valley and Stillwater

Fallon, "Nevada's Oasis," as the welcome signs call it, appears vibrantly green against the backdrop of tan Nevada desert. Long an agricultural center, Fallon and the surrounding Lahontan Valley are irrigated by the Newlands Project, diverting water from the Truckee and Carson Rivers. Some 380 miles of canals and 500 miles of farm ditches irrigate nearly 61,000 acres, which produce alfalfa and hay and support dairy cattle. As water for farming and irrigation becomes more tightly restricted, the Lahontan Valley exhibits the effects. Farmers are under increasing pressure to use less water and to increase irrigation ditch efficiency. Threatened with the loss of their livelihood, farmers in the Lahontan Valley face economic and emotional hardships. Growing urban populations, combined with late-twentieth-century efforts to reverse environmental damage both at Pyramid Lake and at the Stillwater National Wildlife Refuge near Fallon create yet another facet in the increasingly complex set of issues regarding water use in arid lands.

The economy in Fallon has centered, historically, on the farming industry. The presence of the Fallon Naval Air Station and Western Nevada Community College diversify the population, but Fallon's most visible change lies in its urban development. A new strip mall—that American icon of progress—now lines the main drag. Drought irrigation restrictions and the purchase of water rights to restore the wetlands have diminished (though not entirely eroded) the area's agricultural base. These changes have literally paved the way for more housing developments in Fallon and nearby Fernley; simply put, it takes less water to support subdivisions than alfalfa fields. Municipal diversions (water for residential and commercial use) constitute about one-fifth of the total acre-feet used for agriculture. As one farmer told me, regarding the effects of the drought and the reduced allotments of water, "If it hadn't been for the cattle, we would have gone under." He explained that with hay and alfalfa production dropping to 40 percent of normal, the cattle he runs have kept creditors at bay for another year. A local newsletter illustrates the changes occurring in the Lahanton area: under a photograph of a farmer holding a cui-ui on a visit to Pyramid Lake's fishery is the caption that reads, "Two endangered species."

A curious phenomenon occurs as I drive out to Fallon, taking in the river, the intensely

98, 99. Missionary church and Paiute boy, Pyramid Lake Paiute Reservation, Nevada. [rd]

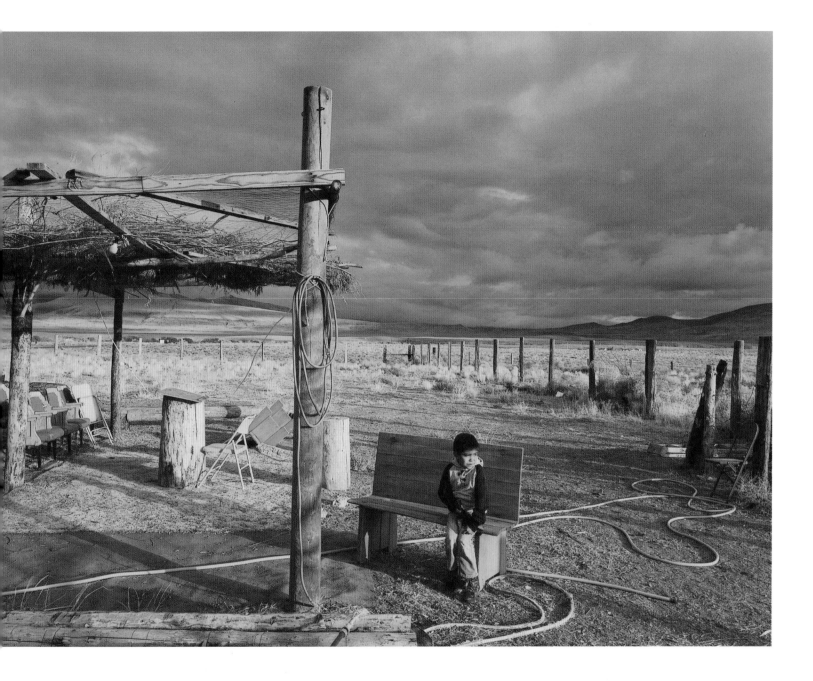

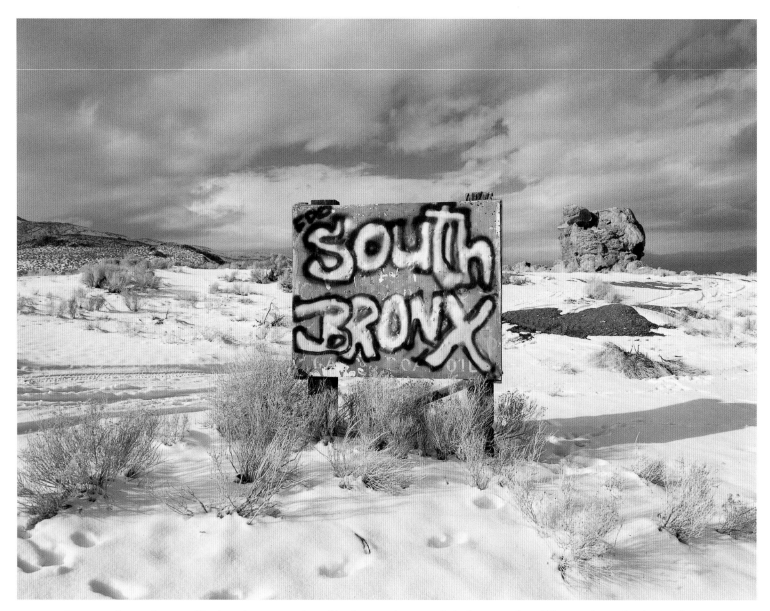

100. "South Bronx" sign on the Pyramid Lake Paiute Reservation. This photograph was made in the town of Sutcliffe, Nevada, on the shores of Pyramid Lake. This grim reminder of despair was painted by a Paiute in response to the poverty and lack of hope that many Indians feel in our culture today. According to Martha Knack and Omer Stewart, "In 1886, James Sutcliffe fenced off thirty acres along the lakeshore where the Reno road branched off. There he built a fishing center and today, still held by whites, this is probably the most valuable piece of property on the reservation. Whites grabbed the last scraps of land in the Truckee bottoms by the end of the 1880s, leaving only the delta and river mouth, directly under the windows of the agency house, in Indian hands. Not only did these white squatters dislodge Paiutes and fence off parcels of land, but they proceeded to utilize a wide range of other reservation resources without compensation. . . . They took water from the river for irrigation as necessary to their farming. Some even drew water out of the BIA [Bureau of Indian Affairs] ditch built by Indian labor. It was not simply a matter of land, but of total, illegal exploitation of the resources of Pyramid Lake, reserved in the name of the Paiutes by the federal government" (Knack and Stewart, *As Long as the River Shall Run*, 192). [rd]

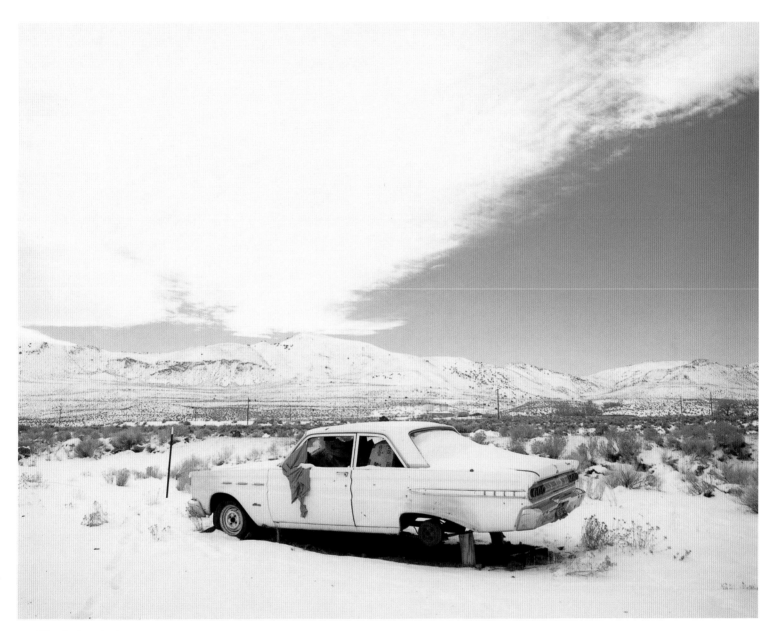

101. Wrecked car in the snow, Sutcliffe. [rd]

green fields, the shimmering cottonwoods: I must confront all my romantic notions about the land. Why am I more sympathetic to these irrigated fields than to asphalt? Why did I laugh when I read a Nevada student's journal entry that said she would "always prefer seeing cattle to condos"? An afternoon spent with Hammie Kent and his family, driving around his 2,800 acres, did little to rein in my transcendental response to this cultivated land that seems so out of place in the austerity of Nevada.

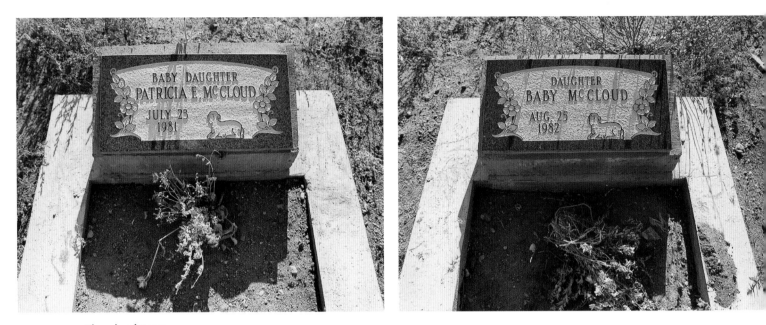

102, 103, 104. Three headstones,
Paiute cemetery, Nixon. [rd]

Our meeting was arranged by a friend from Fallon who had offered to introduce Bob Dawson and me to Mr. Kent. We stopped at Michon's house to pick up directions to the Kent ranch and glimpsed the hospitality that would greet us all day. Michon insisted that we "drop those notebooks and cameras for a moment" and fed us lunch. She then called Mr. Kent to let him know we were on our way.

The early summer day sparkled with a gloriously deep blue sky and a few clouds teasing the Stillwater Mountains to the east. Mr. Kent waited for us at a turn in the road, parked in his gray Ford F-250 pickup. He stepped out to greet Bob and me. A wiry man, he carried his eighty-three years with remarkable grace. He offered to take us around the ranch property, introduce us to his son, who was vaccinating cattle, and tell us the story behind his land. While Bob loaded his cameras and tripod, I climbed into the air-conditioned cab next to Hammie and secretly marveled at his trim condition—agile as a young man, he moved easily in cowboy boots. His face, shaded by a pale straw hat, showed years of Nevada sun exposure. He would later receive our compliments about his

health with a wry smile, graciously allowing, "I've always drank good scotch, breathed the alkali dust, and ate plenty of beef."

Hammie, as Ira Hammill Kent is called, told us how, in 1860, his great-grandfather had purchased part of the land we saw; his grandfather bought 960 acres more in 1876. They irrigated back then by diverting the Stillwater Slough. The implications of this detail surprised me. Kent's family had been farming and reclaiming land thirty-five years before the construction of Derby Dam and the Newlands Project. Hammie's great-grandfather, he told us, had owned the Canvasback Gun Club, a six-thousand-acre hunting preserve that adjoins the Stillwater Wetlands, just beyond his property. As the Stillwater Management Area brochure explains, these wetlands have long provided excellent hunting, even before the arrival of emigrants.

I asked Hammie why his great-grandfather happened to settle here, in this dry land. His response seemed almost mythical: "He had come from New York originally, and

105. Broken glass and frame at dry lake bed near Nixon, Pyramid Lake Paiute Reservation. [pg]

headed out to Oregon, to the Willamette [Valley]. But it was too wet for him there, so he traded horses and got himself to Nevada."

We drove past the fields in cultivation and got a closer look at the slough. "It never ran like that before," he said. "When I was a kid, we'd spend the day getting catfish out of that slough—you couldn't do that now." Like other irrigation ditches we had seen, the water murkily resting in the slough was full of green algae. He suggested the reason for the stagnation might be an upstream sewage treatment plant. We wondered if runoff from fertilizer had caused eutrophication, but Hammie thought differently, saying the reduced water combined with effluent had caused the greening. Hammie mentioned the Clean

106. Open book on desert, Paiute junkyard, near Nixon. [rd]

Water Act, "another way the government is after us," which has mandated that water leaving an irrigated field be just as clean as when it entered. "Can you imagine such a thing?" he asked. "Of course that water won't be clean."

We met Hammie's son Bruce after he finished vaccinating cattle. He described a new ear tag they were using that year. "It works like a flea collar," he said, explaining how the cattle, during their summer grazing months, won't drop as much weight if they aren't moving about to avoid flies and mosquitoes. As we talked in front of his father's home, Bruce gestured toward the Stillwater Marsh, which lies within the Stillwater National Wildlife Refuge and Management Area, and adjacent to Hammie's property.

107. Tufa-covered rock in light, the
Needles, Pyramid Lake. [rd]

One of the largest marshes in Nevada, Stillwater is an oasis for thousands of water-
fowl and shorebirds that migrate along the Great Western Flyway. Like Pyramid Lake,
Stillwater Marsh is one of the last remnants of the ancient Lake Lahontan, the giant lake
that covered much of the Great Basin twelve thousand years ago. Still visible on the nearby
Stillwater Mountains are "bathtub rings," or shorelines indicating the ghostly image of
the Pleistocene lake. As with Pyramid Lake, Stillwater Marsh has suffered the vagaries of
this century's diversions and merging of the waters from two river systems.

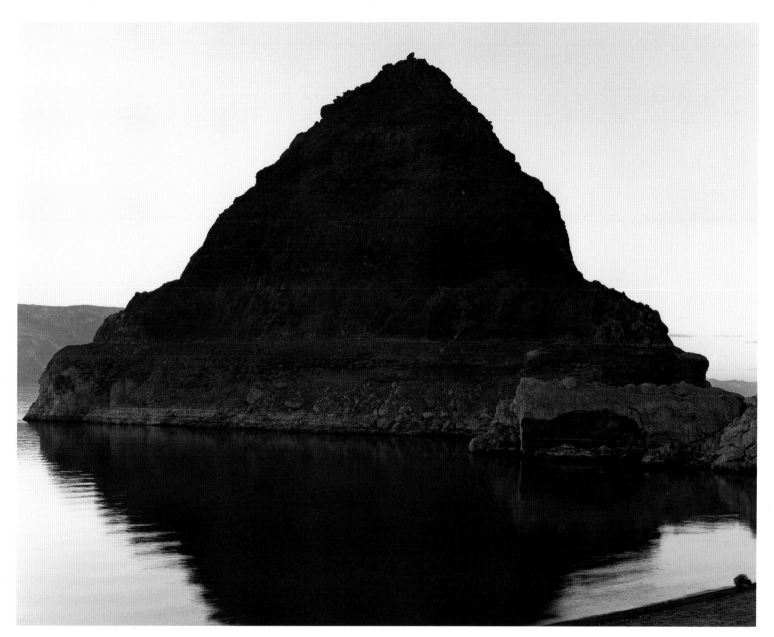

108. After sunset at the Pyramid, Pyramid Lake. [pg]

"It was the efficiency requirement that dried up the marsh," Bruce said, referring to the loss of fresh water that brought national attention (and The Nature Conservancy's efforts) to Stillwater. He explained that updating the ditch systems to use water more effectively actually hurt the wetlands, because less fresh water is returned to the marsh.

We had seen a similar situation earlier that day, when we stopped to look at a yard that used flood irrigation to maintain the grass. Flood irrigation is a process in which a gate from a ditch is opened and the water is allowed to flood the land. We marveled at the con-

109, 110, 111. View from Nixon bridge looking east, Pyramid Lake Paiute Reservation, Pyramid Lake. [pg]

trast, walking through the lush grass covering the flood-irrigated acre and then climbing the ditch bank, where we nearly sank into the sandy soil. The now-efficient concrete-lined ditch had created another set of problems: Water that would have seeped out through the earthen ditch now reaches its destination more effectively; however, it can no longer sustain the mini-riparian systems that once grew alongside the ditch. Once again, we could see how efforts to alleviate one human-created problem had created another.

Some of the Kent property sits within the boundary of the Refuge, and the Kents think they have been good stewards to both the wetlands and to the Stillwater Mountains beyond, where they graze their cattle. Hammie described a visit by a news team reporting on grazing violations. He said they never aired the footage from his place because "that wasn't what they were looking for. Hell, the grass was waving in the wind, right up to the well. But they don't get it: We've been running cattle on those mountains for one hundred and twenty years. If we hadn't taken care of it, we'd have gone broke by now."

Before we left that afternoon, Hammie invited us back anytime, promising to take us

on horseback into the Stillwater Mountains. I was intrigued, eager to get a closer look at those mountains, to see where Hammie had found the curious artifacts that we had seen in his home: numerous collections of arrowheads and a two-hundred-pound grinding stone carved with petroglyphs.

As we drove back to Fallon that afternoon, it was hard not to be romanced by what we had seen: the ranchers, father and son, talking side by side at the trellis under a cotton-wood tree; or the late afternoon light as it made golden the fields of alfalfa, spreading out toward the horizon, speckled with egrets, ibis, and cormorants; the sense of abundance, of comfort and security in seeing the grain, the cattle, the fields of melons and garlic. Another irony occurred to me as we stopped alongside a field to watch the flood irrigation as it soaked the soil. The silence, broken by an occasional blurp of water bubbling into the earth, reminded me that we can be of such different perspectives yet still arrive at the same place.

That place is knowing the land. Another rancher who shared some of his family's history with me is George Frey. According to local legend, George has "come to epitomize mud-hut-to-mansion success in the Newlands area." We talked one sunny June morning on the porch of his rambling ranch house outside of Fallon. The desert heat was mellowed by a steady breeze that blew through the green ash trees shading the backyard. Pots of pansies and sweet william were strategically placed to brighten the redwood deck and the red-and-white-painted farmhouse. Wind chimes caught the moving air. Sipping iced tea, George described the dugout house he and his brother constructed to live in during the 1930s, when they cleared this land.

"It was about twenty by eight," he said, "enough for two or three adults to camp in." They shared it with pack rats, who would nest in the ceiling made of willow and mud. "It [the land] was nothing but brush and timber, hills and hummocks," George reminisced.

This was hard to picture, surrounded as we were by the greenest fields—garlic growing across the way, alfalfa beyond it—and the order of cultivated land.

"Tell her about the bridge," urged his wife, Irene, who had just joined us. She had been chasing down a horse, she said, and she sat next to George, yielding a flyswatter that she used cautiously but quite accurately to keep the flies from lighting on him. A delightful, energetic woman, she kept popping up to refill our iced tea and supply us with homemade chocolate chip cookies. I kept hearing a tinkling sound and realized it came from the spurs on her well-worn boots. She gestured toward the eastern boundary of the ranch.

"That bridge has some history," she repeated. An old one-vehicle bridge spans the Carson River at the entrance to George's ranch. When we arrived that morning, I had made a mental note of the bridge. Constructed of large, weathered pieces of timber, the sign over the bridge proudly announces the Rambling River Ranch. George explained that the bridge had been used at the Lahontan Dam back in the early 1930s. When a new bridge was constructed in 1934, George and his brother tore the old one down to move it to their own property, bit by bit.

"We used old hot-water heaters filled with rocks to act as pilings." Looking around the ranch, I could see other evidence of such ingenious re-uses: Discarded barn wood fenced the backyard; flowers filled an old bathtub under one of the ash trees.

George's family had come west to Genoa, Nevada, the first Mormon settlement in the Territory back in 1854. His mother's people were Peckhams, an old Reno ranching family. George's children and grandchildren are, as he said, "on the tractors at two in the morning." The ranch is not only his livelihood, he says; his roots are in that land.

"I tell people we're want-to-be, not had-to-be, farmers," he said.

Nearby ranches are failing, some from poor management or bad timing. The land

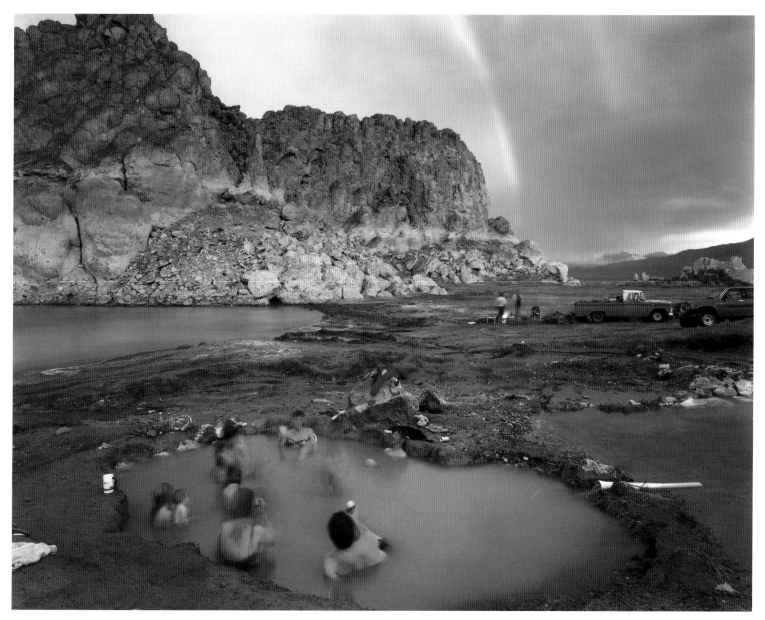

112. Party with rainbow at the hot springs, the Needles. This popular spot for recreationists, at the north end of Pyramid Lake, contains many tufa rock formations and several natural geysers. The Needles area is now closed to nontribal members. [rd]

113. Hot springs and diversion debris, the
Needles, Pyramid Lake. [pg]

might have been bought at too high a price, George explained. Now the bank is calling in
the notes, and farmers have no choice but to sell. Recently, the buyer has been The Nature
Conservancy. The Nature Conservancy purchases the water to ship it from formerly culti-
vated land out to the Stillwater Wildlife Refuge. The problem, according to George and to
Mary Reid, a water resources specialist for the University of Nevada Cooperative Exten-
sion service, is that fallowed land benefits no one. Without revegetation of some kind,
the previously farmed acreage becomes "wasteland," as George called it, filled with

tumbleweeds and other invasive plants that are carried by wind and water to neighboring ranches.

"It's not only a matter of aesthetics," said Irene, referring to irrigators and the effects of restoring the wetlands. "What people don't understand is that new irrigation systems, ones that conserve water and are efficient, are expensive." She indicated the garlic bulbs drying on the table in front of us. "We switched over to drip irrigation for the garlic, and that saves water. But you can't grow everything with drip—it's too expensive for alfalfa, for example. And it's hard to get such a system going in a drought, so some farmers have had to sell out. That means an end to a whole community. This land is too valuable to just be left alone. If The Nature Conservancy doesn't buy it, developers will."

Farmers like George and his family have achieved one version of the American dream. They live off the land, and they work at what they love. Yet this lifestyle, dating back a hundred years and embedded in our very culture, was imported at an enormous cost to the environment and to the native population. Perhaps the most compelling evidence of the Newlands Project's implications can be seen at the Stillwater National Wildlife Refuge, the last place where water from the Truckee and Carson Rivers drains into the desert. Located in the Lahontan Valley north and east of Fallon, the wildlife refuge has been plagued by fluctuating water levels from drought and diversions, but it has begun its redux since the wet winters of 1995, 1996, 1997, and 1998.

The Newlands Project, which diverted on average 50 percent of the annual flow from the Truckee River (and about 95 percent of the water during earlier drought periods, such as in the 1930s, until 1967), required another reservoir to be built on the Carson River in 1915. This reservoir, named for the ancient Lake Lahontan, stored transported water from the Truckee and Carson Rivers until farmers used it for irrigation. As flows from the Truckee River into Pyramid Lake diminished, Pyramid Lake's sister lake, Winnemucca, dried up completely. Similarly, as fresh water that charged the wetlands began to be replaced by a diminished supply of agricultural drainage water, Stillwater began to dry. Naturally occurring trace elements—arsenic, boron, lithium, molybdenum, and selenium—leached from the soil and began to accumulate in the wetlands, causing birth defects and death in birds and fish.[1]

Ironically, as the farmers were ordered to get by with less irrigation water, the situation at Stillwater became worse. "Reducing the farm water also intensified the toxicity problem, because the concentrations of naturally occurring elements in the water increased. Instead of a wildlife reserve, Stillwater was becoming a toxic menace," writes Don Vetter. "In 1987 and 1988, it became a regular chore for biologists to gather up dead birds and fish that would wash ashore at Stillwater and Carson Lake."[2]

The Refuge is similar to Pyramid Lake in many ways. Both are terminus points for the

114. Family and recreational equipment at the Needles, Pyramid Lake. [rd]

two major rivers, the Carson and the Truckee, respectively. Both the Refuge and Pyramid Lake have manifested impacts from the drought as well as from Newlands Project diversions. Both have been sources of controversy in the litigation of the Truckee River. The scoreboard showing water rights won or lost inevitably lists not two adversaries, but numerous opponents for the overcommitted Truckee: urban water users, Lahontan Valley farmers, the Pyramid Lake Paiute Tribe (and the cui-ui), and the Wetlands Coalition (and migratory birds). The U.S. Bureau of Reclamation, which oversees the Newlands Project, as well as federal and state fish and wildlife agencies also have their say in the dividing of

115. Lone fisherman in Pyramid Lake. [rd]

116. Swimmers adjusting to the cool water, Tenth Annual Pyramid Lake Triathlon. [pg]

117. U.S. Fish and Wildlife biologist Anne Janik counts white pelicans on Anaho Island, Pyramid Lake, while Anita Kang DeLong, refuge operations specialist, records the count. The birds feed on the lake's endangered cui-ui fish when they spawn in the spring. Anaho Island, a 750-acre national wildlife refuge located in the mid-to-southern part of the lake, is one of the seven largest breeding and nesting areas in the western United States for white pelicans. The white pelican has the largest wingspread—up to nine feet—of any bird in the North American continent. White pelicans nest in the spring and raise their chicks in the summer, migrating to Southern California and Baja California in Mexico during the winter months. They have probably been nesting on Anaho Island for thousands of years. Over the past fifty years, the average number of chicks produced on Anaho is 3,000, with the highest nearly 10,000 and the lowest, 9. [pg]

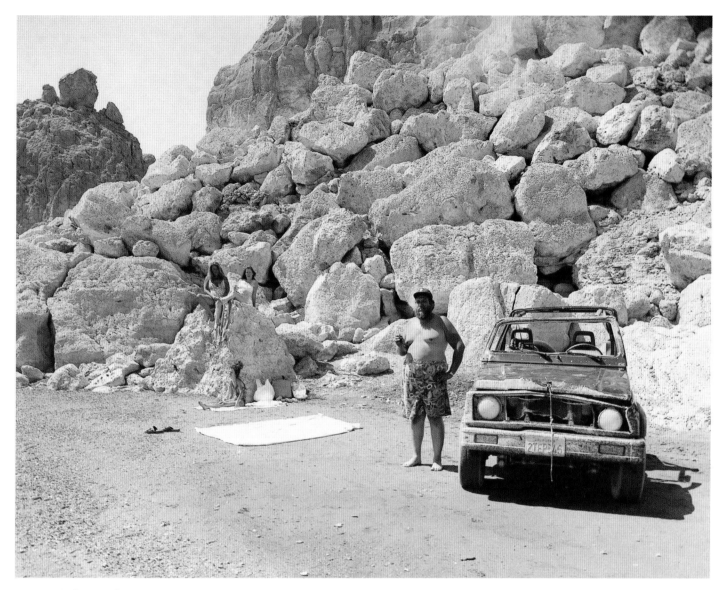

118. Family from Herlong, California, picnicking at the Needles, Pyramid Lake. [pg]

the water. Thus, when decisions are made to return more water to Pyramid Lake for the endangered cui-ui, not only are downstream farmers affected, but the tail end of the system, the Stillwater Wetlands area, is affected as well.

According to a recent Nature Conservancy brochure, "The Lahontan Valley Wetlands [of which Stillwater is a part] are designated as one of only seventeen Hemispheric Shorebird Reserves in the world . . . and are internationally recognized as a critical link in the chain of primary migratory, breeding, and wintering sites which comprise the Pacific Flyway."[3] Stillwater is home to hundreds of species of shorebirds and waterfowl; it "hosts a significant percentage of the Pacific Flyway's canvasbacks, redheads, tundra swans,

119, 120, 121. Tire tracks on Winnemucca Lake, sister lake to Pyramid Lake. Winnemucca Lake was named for Chief Winnemucca, a nineteenth-century tribal leader. This lake is fed by a slough from Pyramid Lake. Winnemucca Lake is also known as Mud Lake. It dried up in the 1930s and has had only shallow accumulations of water in it since then. [rd]

122, 123, 124. Dry lake bed, Winnemucca Lake. [pg]

gadwalls, northern shovelers, green-wing teals, and ruddy ducks, along with the largest breeding colony of white-faced ibis in North America. . . . Up to 70 bald eagles, Nevada's largest concentration, winter in the valley and American peregrine falcons are known to visit," states a Fish and Wildlife Service bulletin.[4]

One winter Sunday, with borrowed binoculars and the promise of viewing a heron, I visited Stillwater. Clouds and blue sky made a dramatic play of light and shadow as I drove east along the Truckee River on that beautiful, bright morning. Hills along the interstate glowed in russet, lilac, and browns, and the river itself sparkled. The trees, stands of cottonwoods, gnarled and pale in their winter nakedness, stood over the river. Grasses of tan and gold waved in the sunlight. Even in winter, everything appeared drenched in vivid colors, from the leafless trees to the rust-colored tamarisk along the riverbank.

I paid special attention to the markers I saw along the way, once past the town of Fallon. Stillwater, one marker informed me, was named for the large pools of tranquil water nearby. Once there was a town at this site, which served as the county seat before Fallon, according to Hammie Kent. Like other nineteenth-century towns, Stillwater originated as an overland stage station. Area farmers supplied mining camps with produce.

The Refuge encompasses 22,000 acres, according to the historical marker along the road to Stillwater. The wetland habitat was designated as a national wildlife refuge in 1943, though it has been there much longer. In 1948, according to a Nature Conservancy brochure, "the U.S. Fish and Wildlife Service and the Nevada Fish and Game Commission entered into an agreement with the Truckee-Carson Irrigation District to develop and manage 224,000 acres of Bureau of Reclamation/Newlands Irrigation Project lands for wildlife and grazing. . . . In 1991, 77,500 acres of the management area were set aside as the Stillwater National Wildlife Refuge."[5]

When I arrived at the "National Wildlife Viewing Area," I saw the Stillwater Range, Hammie's mountains, to the northeast; a cold wind blew from their direction. The mountains were veiled in clouds and had quite a bit of snow on them. The Stillwater marshes teemed with bird sounds emanating from tall grasses and cattails. As I listened to the familiar honk of geese and ducks, I watched a red-tailed hawk soar in the distance. After standing out in the wind for a few minutes, staring very inexpertly through my binoculars, I recognized a great blue heron. This large gray-blue bird perched on the bank of the pond for a long time. Watching it through my small pair of binoculars, I could see the faintly blue feathers, the long beak, and the height of the bird. Its beak disappeared from time to time into the pondweed and nut grass. I stood, balancing my elbows on the roof of my car to steady my arms, and just watched. The absence of usual noise was incredible. No cars, no people. The only sound was the wind, gusting across the marshlands. When the heron took flight, I watched its huge wings patiently moving the air until it disappeared.

125. Algae growth in alkali, dry lake bed, Winnemucca Lake. [pg]

I spent hours listening to the wind, watching herons and hawks. As I wandered down one dirt road, I stopped breathing for a moment as I recognized a group of tundra swans, turning toward the wind and then away, as the water below them shimmered. The cold north wind and gathering clouds finally drove me back into the car to warm up. The thermos of coffee steamed my car windows. I continued to sit, enchanted by the quiet and play of light on the clouds. That this place, like Pyramid Lake, might have been permanently lost was a horrifying thought. Perhaps more disconcerting was that the fates of these two independent ecosystems were now inextricably linked by human alterations of nature.

126. Beach lines, Winnemucca Lake, north end. These lines are reminders of the declining shoreline of Winnemucca Lake after the 1906 diversion of the Truckee. This lake was once part of the ancient Lake Lahontan, which covered much of the Great Basin. [pg]

Pyramid Lake Stories The End of the Truckee River

You don't have anything if you

don't have the stories.

—Leslie Marmon Silko, *Ceremony*

Anything I might write about Pyramid Lake has an underlying premise—that I am trespassing, in written word as well as in my presence there. The lake's spiritual qualities are well known to Paiutes, who have made their home by its shores for thousands of years. For the rest of us who venture to the lake, the healing power of that water is both palpable and frightening. The desert lake is home to a prehistoric fish, the cui-ui, once a major food source for Paiutes. The Paiute name for Pyramid Lake is cui-ui-pah, or cui-ui water. This lake also houses within its depths the remains of countless victims of drownings and plane crashes. Despite this mysterious and fearful quality, the lake heals both psychically and physically. To spend an afternoon swimming in its turquoise water brings a sense of peace, helps me to forget that beyond the reservation boundaries, new homes, new tract sites develop each week. The quiet sound of waves lapping on the beach, the sensation of effortless floating in that alkaline water, with only the company of gulls and pelicans, calms me.

Driving to Pyramid Lake, however, fills me with a mixture of pleasure and dread. The road winds through what used to be open spaces, great long valleys full of shadows and sagebrush and an occasional juniper tree. But in many places, tract after tract of pastel houses displace the desert. Signs between the tracts announce the impending arrival of shopping centers and a new high school. Most of the new homes are surrounded by large lots, one-third or one-half acre, and nearly all sport green lawns.

In most of the tracts, the model homes are set off by all-rock landscaping, but the sales staff will tell you that the more elaborate (more green) the landscaping, the better the resale price of the property.

Where is the water for these homes to come from, I ask a sales agent. She tells me that water rights are secured for this development, and she points up the hill at a water tank. All the way up the hills, into the juniper, lie 550 homesites. I have managed, on my various drives out to Pyramid Lake, to deny this possibility until now. I ask, "So this has all been approved?"

128. Naturally irrigated desert land
near Fallon, Nevada. [rd]

the treatment of her people and traveled the country lecturing. In this account of white aggression, we get a different view of the ill-fated Donner Party, who apparently interacted with Paiutes. Before they reached their catastrophic fate in the Sierra snows, the Donner Party left an indelible mark on the Pyramid Lake Paiutes. Sarah Winnemucca writes:

> While we were in the mountains hiding, the people that my grandfather called our white brothers came along to where our winter supplies were. They set everything we had left on fire. It was a fearful sight. It was all we had for the winter, and it was all

129. Flood-irrigated desert land near Fallon, Nevada. [rd]

burnt during that night. My father took some of his men during the night to try and save some of it, but they could not; it had burnt down before they got there.[3]

Her account goes on to explain that this party perished in the Sierra snow, starving and resorting to cannibalism. According to oral histories, later generations of Paiute and Washoe Indians related shock toward this cannibalism and noted how it underscored further their dread of white men, "cannibals both of land and of body."[4]

The Paiutes' economy, for so long dependent upon mobility and flexibility, has since

130. Two generations of Nevada ranchers: Bruce and Hammie Kent at home. Their ranch abuts the Stillwater wetlands, near Fallon, Nevada. [rd]

the arrival of whites been subject to the variable levels of Pyramid Lake. Legislation signed into law in 1990 attempts to apportion enough stored water to sustain the lake at healthy levels. Despite all its legal entanglements, the lake dominates Paiute cosmology. In more than one conversation with Mervin Wright Jr., then Paiute tribal chairman, I have learned that for Paiutes, water is life. In his role as water resources director, Mervin orchestrated the tribe's concerns in the Negotiated Settlement, the process by which the five entities claiming an interest in the Truckee River system will come to terms. There is an intensity about this man that his easygoing expression seems to contradict; his animated smile and sense of humor belie a person fighting a great deal of cynicism. His black hair falls to his shoulders, framing almond-shaped eyes and high cheekbones. He has seen how the bureaucracy (both in white and in native societies) fails, how favoritism causes mismanagement of both money and programs.

Our talk centered on the Paiute story of the Stone Mother, a rock formation on the eastern shore of Pyramid Lake. The Stone Mother's tears filled Pyramid Lake in the ancient time, he said. Her tears were shed because her husband, a gentle, peace-loving man, could no longer tolerate the fighting between their sons. So he split up her family, sending away her warring sons to form other tribes. The husband also went away, leaving the Stone Mother all alone. One day, overcome by her sadness, the Stone Mother knelt down in the sand and began to cry. Her tears drained all the water from her body, which created the lake; her body then turned to stone. Other lakes in the area, Summit and Eagle Lakes to the north and Honey Lake to the west, represent the tribes of those lost sons. The interconnectedness of these lakes conveys the importance of land and water, as well as their inseparable nature.

Everything in this world is related, according to Mervin's view of Paiute cosmology. *Pah* means water in Paiute, and their creation stories bear out its importance. "The first thing that was created was the rocks," Mervin told me. "And after the rocks came the water. Plants and trees came next, and they were called our sisters; and then animals, and they were called our brothers. So you see, we are all living beings, all belonging to the earth, and not the other way around. This isn't our lake," he said, pointing toward Pyramid Lake. "We belong to it."

Mervin pointed out that his people live in a world where, as he says, the physical things, things that can be touched, are the most important, like the water, rocks, heat, and steam. "Earth gives us many resources," he said, noting the bitterbrush, juniper, and sagebrush. "We must respect them, water above all."

Mervin related a conversation he had with a water company official in the dryest months of the drought. "She asked me if the Tribe would be willing to adjust the agreement [Truckee River Operating Agreement] to say that water in Stampede Reservoir would

131. Truck Inn truck stop near Fernley,
Nevada. [rd]

be used for M & I [municipal and industrial needs] in the event that the drought continues.
She talked about landscapers, one group who will be very hard hit. 'How will they feed
their families,' she asked me, 'if the water restrictions get any tighter and lawns die?' I told
her, 'What's more important here? Lawns or a people's culture and livelihood? Why can't
they implement xeriscapes? That would keep them in business. But people want green
grass in the desert.' Why should we rob from the lake just so people in Reno and Sparks
can water their lawns? Lawns are expendable. People aren't."

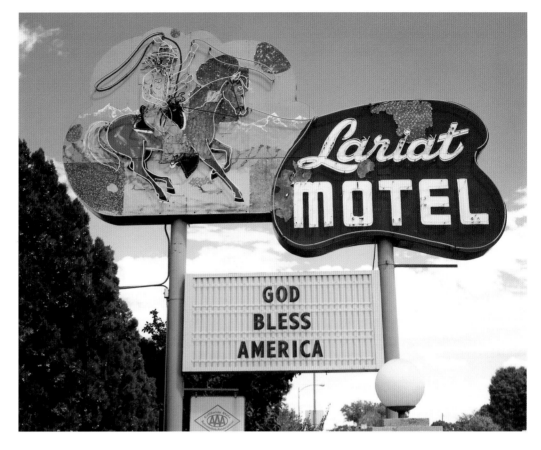

132. Neon sign at the Lariat Motel, Fallon, Nevada. [rd]

Gretel Ehrlich writes, in *The Solace of Open Spaces*, "Everything in nature invites us constantly to be what we are. We are often like rivers: careless and forceful, timid and dangerous, lucid and muddied, eddying, gleaming, still." She compares nature's dry spells with those we experience spiritually as "dormant periods in which we do no blooming, internal droughts only the waters of imagination and psychic release can civilize." Ehrlich's metaphoric description of drought and characterization of nature's cycles provide an appropriate way to consider our impact on arid land. For we are like rivers, muddied or lucid or drying. We must understand and adapt to this arid country's delicate balance of wet and dry. This doubtful river's stories, like our own lives, will continue to shape themselves against a backdrop of changes: population growth, drought, and flood. Ultimately, our actions carry the strongest impact on Pyramid Lake and the Truckee River. Let us listen to the stories they tell us.[5]

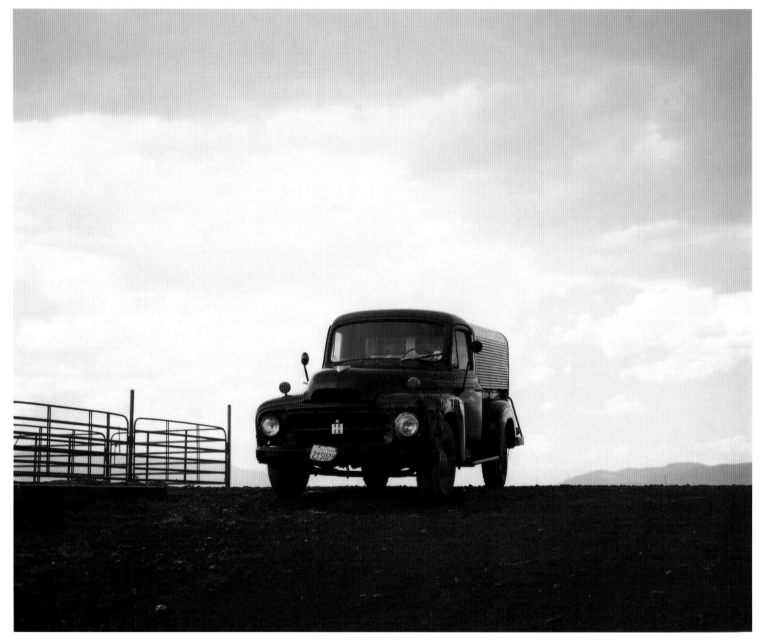

133. Truck in approaching rainstorm, Fallon, Nevada. [rd]

Listening Lessons of the Truckee River

The land holds a collective memory

in the stillness of open spaces.

Perhaps our only obligation is to

listen and remember.

—Terry Tempest Williams,

An Unspoken Hunger

Although these essays interpret the present culture of one western river system, the stories of our expanding presence in the arid West always return to the cycles of human activity within nature. As this century comes to a close, the Truckee River looks considerably cleaner than it did one hundred years ago, when sawmills dumped loads of debris into it. In June of 1999, the Truckee River sports whitewater once again. Five consecutive wet winters (1994–1998) brought not only record-breaking snowpack but the Great New Year's Flood, as the flood of January 1997 was called. The Truckee River looked anything but doubtful as it surged along, carrying trees, debris, and the homes and property of many. The flooding had its origins in a crippling December solstice snowstorm that brought more than eight feet of snow to Donner Summit and even three feet as low as Reno's valley floor. Then warm Hawaiian air, termed the "pineapple express," brought tropical moisture to as high as 9,000 feet, melting the enormous snowpack and sending a torrent from Lake Tahoe down the mountain through the floodplain in the Truckee Meadows. So much water flowed into the Truckee that the level of Pyramid Lake rose eleven feet.

At the summer solstice, Peavine Mountain appears out my office window, now clothed in the customary browns of summer. Despite the moisture of the past winter and spring, the desert mountains surrounding Reno are swathed in their summer tans. "Mount Peavine," as this basin-shaped peak is called, is the last peak of the Carson Range. It rose with the Sierra Nevada and moved sharply, leaving a steep fault scarp on its northeast flank. Both the Washoe Indians and the Northern Paiutes considered it sacred; the Washoe called it "the upside-down mountain," and the Paiutes, "Sunflower Mountain." They traveled along this ancient lifeway to gather sunflower seeds from Mount Peavine. It stands 8,264 feet tall; the Anglo name comes from the wild peavine, a type of vetch that grows on its upper slopes.

After a summer of dry, hot days, Peavine is still rich with water. Small, ephemeral streams are flowing, and lush green grasses and wildflowers abound. Sego lilies, red Indian paintbrush (and yellow and orange), lupine, sunflowers, primrose, globe mallow,

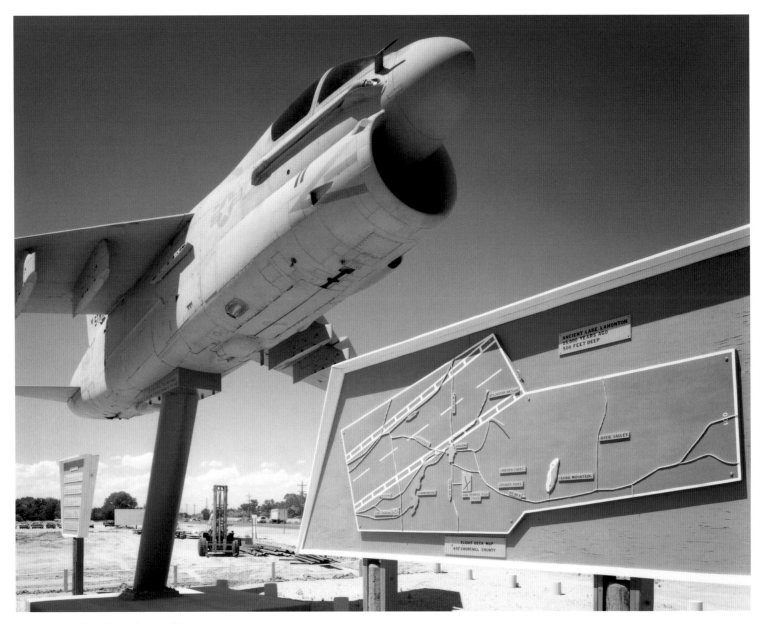

134. Juxtaposition: jet and map of the ancient Lake Lahontan and present-day Churchill County, Fallon, Nevada. Fallon now houses the Naval Strike and Air Warfare Center, site of the renowned Top Gun training center. [rd]

135. Simulated tank, Bravo 17 Bombing
Range south of Frenchman, Dixie Valley.
This bombing range is one of four
bombing ranges for the Naval Strike and
Air Warfare Center, Fallon. [pg]

136. Irrigated agriculture and
Newlands Canal near Fallon.
[pg]

and penstemon flourish. Peavine Mountain, draining to the Truckee River just a few miles
away, provides a fitting, though frightening, image with which to conclude this narrative.

"Normal" precipitation in the Truckee Meadows totals about seven inches annually.
Wet cycles, like the winters of 1994–1998, brought additional precipitation, averaging four
to five inches beyond the norm. Such moisture, such winters, incline us to forget about
periods of drought, but experience tells us that the dry periods will return. The snow and
ensuing floods have diluted any willingness to restrict our consumption of water as
the Truckee Meadows continues to grow. We have survived the immediate crisis, and some
of us even changed our water-using habits, but the city's growth has not changed be-
cause of it.

Developments proliferate; some are built on landfill—where once a wild ravine carried

137. Algae in Stillwater Slough, at
the Kent Ranch, Stillwater, Nevada.
[rd]

runoff from Peavine, now fill dirt and machines sculpt the land for future homes and tamp down foundations for yet another shopping center. The economy thrives, and newcomers arrive daily to take jobs in construction or wait for prospective ones in downtown's newer casinos. The feeling, at least at city hall, is enthusiastic, though the sentiments among my neighbors and acquaintances seem more cynical than ever. If anyone mentions growth in Las Vegas, we all shiver and reckon that things here aren't as bad as they could be. As one woman I chatted with at the dentist's office remarked, "Yes, there are more jobs now, but

138. Ice-covered marsh, Stillwater National Wildlife Refuge. [rd]

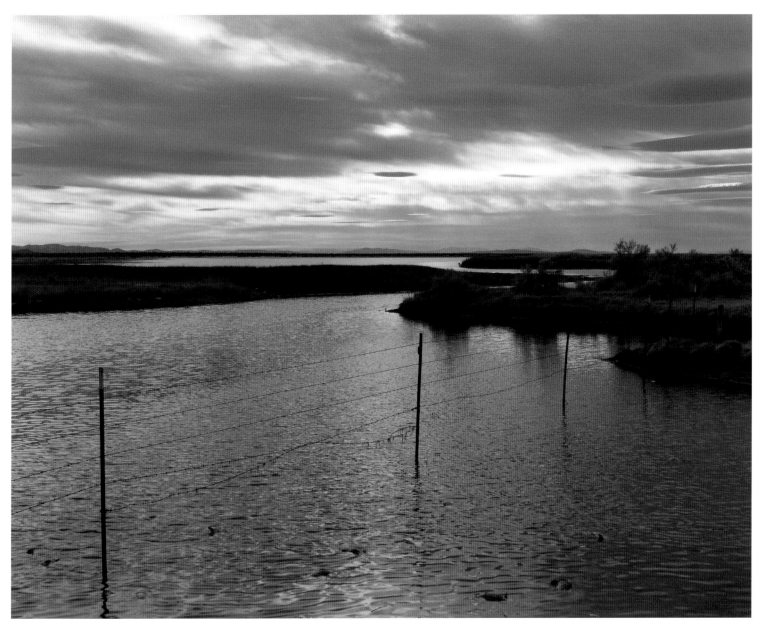

139. Dead fish floating along the shore. Increasing salinity, combined with decreased fresh water to recharge the wetlands, resulted in fish dying at the Stillwater National Wildlife Refuge during the 1987 drought. [pg]

140, 141. Tumbleweeds on ice, Stillwater National Wildlife Refuge. [rd]

what sort of jobs are they offering to people? Minimum-wage jobs. People can barely rent a place to live, much less buy one. What kind of community are we building here?"

This current boom cycle, like others before it, brings up the same questions for people living in arid lands—how do we live within the context of aridity? As Tucson writer and desert advocate Charles Bowden warns, "The defense underlying all proposed changes is simply that they will actually change nothing. It does not matter whether the instruments of our pleasure are chainsaws, dams, highways, toxic waste dumps, or houses." He argues further that we should not give in to "trade-offs": "Trade-off has a crazed ring to me. It always sounds like the canyon that has been gutted, the stream polluted, or the tree that has been killed has actually just been traded off and is now happily playing Triple-A ball for some team in San Diego."[1]

What Bowden decries on Tucson's Frog Mountain (the native Tohono O'odham name for Mount Lemmon) echoes in the unoccupied pads of strip malls and across other developments in the Truckee Meadows. Now, as nearly a century before, profit and optimism motivate our actions rather than empathy for the land and the river. The consequences of our heedlessness surround us. Drive into the sunset on the interstate highway and notice as the last rays of sunlight reflect on the myriad of broken bottles, fast-food cups, and wrappers. Randomly check nearby desert hills and mark the abandoned bedsprings, bullet-ridden shells of former automobiles, television sets, and washing machines. The

142. Photographer's friend holding a large example of the tumbleweed, introduced species and symbol of the West. Stillwater Wildlife Management Area. [pg]

143. Low water at Stillwater Wildlife Management Area. [pg]

145. Canvasback Gun Club within Stillwater Wildlife Management Area. [pg]

144. Stillwater Slough and Randy Weishaupt property looking north to Canvasback Gun Club. The Nature Conservancy purchased the land in 1995. [pg]

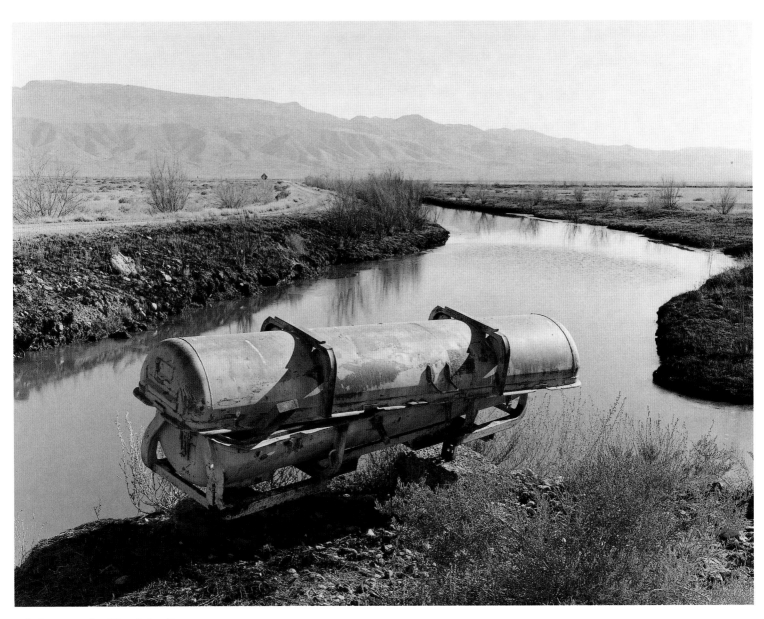

146. Storage pod at Olano's Landing,
Stillwater Wildlife Management Area.
[pg]

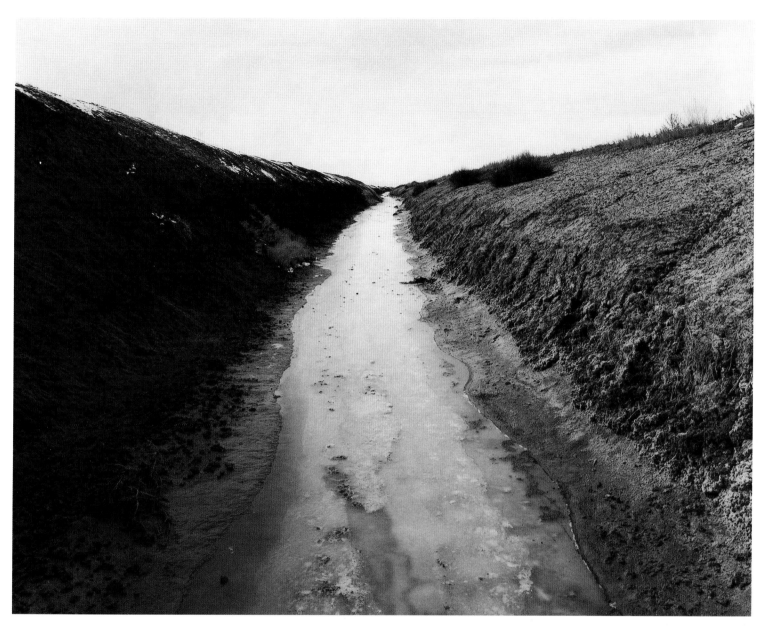

147. Ice-covered canal, Stillwater National Wildlife Refuge. [rd]

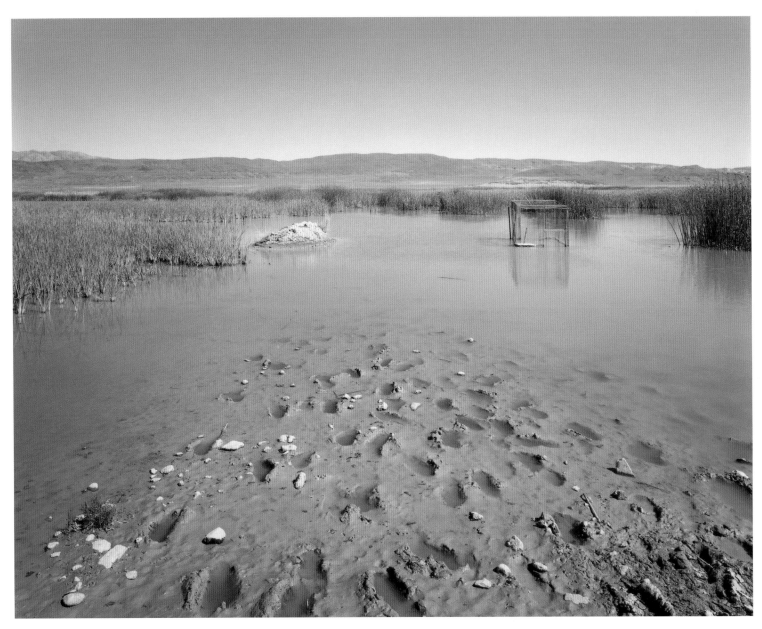

148. Footprints into marsh, Stillwater National Wildlife Refuge. [rd]

glittering remnants of human consumption declare, this land *is not our land at all*; this is land for which we feel no kinship.

Neither human efforts nor the effects of flooding can totally restore Pyramid Lake and the Lahontan Valley Wetlands; we cannot undo the reclamation of the desert any more than we can dismantle our present culture. Water-rights acquisition programs initiated by the U.S. Fish and Wildlife Service, the Nevada Division of Wildlife, the Nevada Waterfowl Association, and The Nature Conservancy, along with Public Law 101–618, have improved

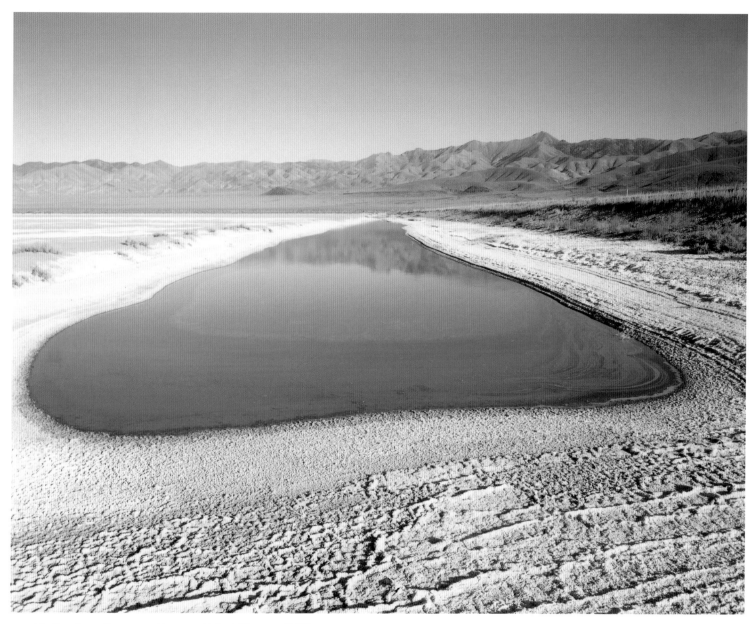

149. Alkali and standing water, Nutgrass Unit, Stillwater Wildlife Management Area. [pg]

150. Stillwater Marsh in healthy condition. Photograph by Dave Marshall, 1949. U.S. Fish and Wildlife Service.

conditions at both Pyramid Lake and the Wetlands. But the acreage of wetlands today accounts for less than 5 percent of their pre-European-settlement size. Figures pre-1845 show over 150,000 acres of wetlands; since 1990, that figure has dropped to as low as 3,500 acres of healthy wetlands.

Mervin Wright Jr. reminds me that the Negotiated Settlement hasn't yet been signed. "Maintenance of water quality is still at issue," he said, affirming that until those negotiations are complete, the Pyramid Lake Paiute Tribe will not be compensated, per Public Law 101–618.

We cannot undevelop the open spaces. What we can do is learn from the Truckee River. We can learn to live with aridity, which in fact is our only choice, given that population growth in the Truckee Meadows is projected to surpass 250,000 in the next five years. We can listen to the river and to the landscape it drains. This doubtful river has much to teach us.

When I leave my office, I will walk on Peavine. Doing so brings me an awareness of the

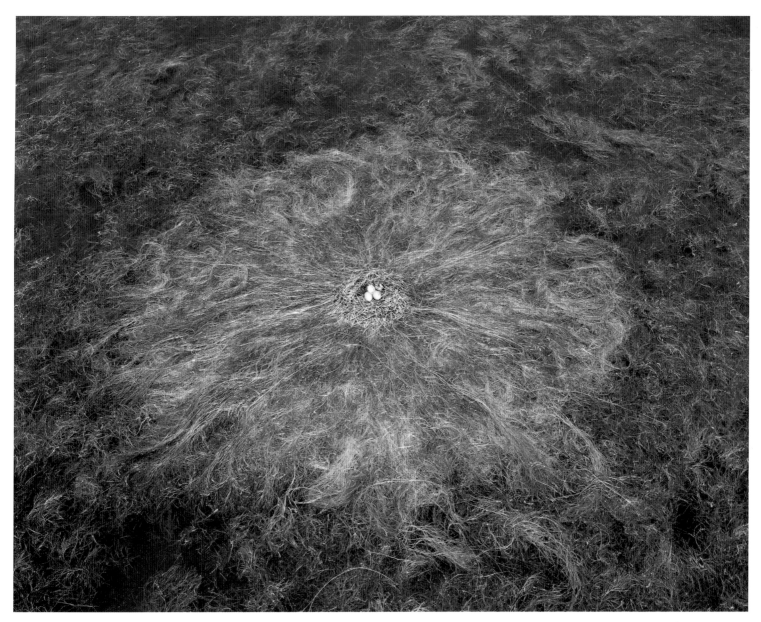

151. Eared grebe nest and spiral grass, Goose Lake, Stillwater National Wildlife Refuge. [pg]

mountain and the changes each day, each season brings. I will study the rocks themselves, a combination of volcanic rocks and granite boulders, their gray surfaces veined with yellows and lavenders, glowing in the lengthening shadows. I'll breathe the spicy aroma of sagebrush, which covers the mountain, and notice the trash that has been dumped, and look toward town, see the winding green that marks the Truckee River, and know how intricately tied we all are.

Go out and listen; only then can we understand ourselves and the limits of our own backyards, wherever they may be.

Notes

CHAPTER ONE

1. *The WPA Guide to 1930s Nevada: Nevada Writers' Project of the Work Projects Administration* (1940; reprint, Reno: University of Nevada Press, 1991), 11.
2. Martha C. Knack and Omer C. Stewart, *As Long as the River Shall Run: An Ethnohistory of Pyramid Lake Indian Reservation* (Berkeley: University of California Press, 1984), 48.
3. Thomas J. Lyon (ed.), *This Incomperable Lande: A Book of American Nature Writing* (Boston: Houghton Mifflin, 1989), 18.
4. Quoted in Sessions Wheeler, *The Nevada Desert* (Caldwell, Id.: Caxton Printers, 1971), 36.
5. Quoted in ibid., 48.

CHAPTER TWO

1. Isabella Bird, *A Lady's Life in the Rocky Mountains*, edited by Ann Ronald (Sausalito: Comstock Editions, 1987), 9.

CHAPTER THREE

1. Knack and Stewart, *As Long as the River Shall Run*, 266.
2. Ibid., 286.
3. Sarah Royce, *A Frontier Lady: Recollections of the Gold Rush and Early California*, edited by Ralph Henry Gabriel (New Haven: Yale University Press, 1932), 32.
4. *WPA Guide*, 136.
5. Knack and Stewart, *As Long as the River Shall Run*, 292.
6. Ditchrider's report, April 1928, in Claude Dukes Papers, Special Collections, Getchell Library, University of Nevada, Reno.
7. Knack and Stewart, *As Long as the River Shall Run*, 293.
8. Edward Abbey, *Desert Solitaire* (New York: Random House, 1968), 272.
9. Knack and Stewart, *As Long as the River Shall Run*, 269.
10. Ibid., 267–68.
11. Ibid., 269–70.
12. Wallace Stegner, "Living Dry," in *Where the Bluebird Sings to the Lemonade Springs: Living and Writing in the West* (New York: Penguin, 1992), 75.
13. *Reno Evening Gazette*, 17 August 1934, p. 1.
14. Tom Power, "Lycra Is as Authentic as Denim," *High Country News* 26 (2 May 1994): 11.
15. Ibid., 12.

CHAPTER FOUR

1. Quoted in Knack and Stewart, *As Long as the River Shall Run*, 67–68.

2. Ibid., 72.

3. Ibid., 84.

4. Carrie M. Townley and Patricia Stewart, *S-S Ranch and the Lower Truckee*, pamphlet of the College of Agriculture, no. 2 (Reno: University of Nevada, 1978).

5. *WPA Guide*, 139.

CHAPTER FIVE

1. Don Vetter, "Teeming Oasis or Desert Mirage? Bringing a Wildlife Refuge Back to Life," *Nature Conservancy* 41 (Sept./Oct. 1991): 22.

2. Ibid.

3. The Nature Conservancy, "Living in Balance," brochure (Reno: The Nature Conservancy, n.d.), 6.

4. Ralph Swanson, "New Legislation Aids the Recovery of Endangered Fish and Refuge Wetlands in Nevada," *Endangered Species Technical Bulletin* 17 (Washington, D.C.: U.S. Department of the Interior, Fish and Wildlife Service, 1992): 11.

5. The Nature Conservancy, "Living in Balance," 6.

CHAPTER SIX

1. Royce, *A Frontier Lady*, 36; Bird, *A Lady's Life in the Rocky Mountains*, 6.

2. State of California, *Truckee River Atlas* (Sacramento: State of California, Resources Agency, Department of Water Resources, 1991), 26.

3. Quoted in Knack and Stewart, *As Long as the River Shall Run*, 41–42.

4. Ibid., 42.

5. Gretel Ehrlich, *The Solace of Open Spaces* (New York: Viking, 1985), 84.

CHAPTER SEVEN

1. Charles Bowden, *Frog Mountain Blues* (Tucson: University of Arizona Press, 1994), 162–63.

Suggested Readings

The references cited here are intended as preliminary resources for water, landscape issues, literature, and photography in the American West.

Austin, Mary. *Land of Little Rain.* New York: Ballantine Books, 1971.

Houghton, Samuel. *A Trace of Desert Waters: The Great Basin Story.* Glendale, Calif.: Arthur H. Clark, 1976. Reprint, Reno: University of Nevada Press, 1994.

Knack, Martha, and Omer Stewart. *As Long as the River Shall Run: An Ethnohistory of Pyramid Lake Indian Reservation.* Berkeley: University of California Press, 1984. Reprint, Reno: University of Nevada Press, 1999.

Limerick, Patricia Nelson. *The Legacy of Conquest: The Unbroken Past of the American West.* New York: W. W. Norton & Company, 1988.

Lippard, Lucy R. *The Lure of the Local: Senses of Place in a Multicentered Society.* New York: New Press, 1997.

McPhee, John. *The Control of Nature.* New York: Farrar, Straus & Giroux, 1989.

Nabhan, Gary Paul. *The Desert Smells Like Rain.* San Francisco: North Point Press, 1987.

Naef, Weston. *Era of Exploration: The Rise of Photography in the American West, 1860–1885.* Boston: New York Graphic Society, 1975.

Palmer, Tim. *Endangered Rivers and the Conservation Movement.* Berkeley: University of California Press, 1986.

Reisner, Marc. *Cadillac Desert: The American West and Its Disappearing Water.* New York: Viking Penguin, 1986.

Ronald, Ann. "Why Don't They Write About Nevada?" *Western American Literature* 24, no. 3 (1989): 213–24.

Stegner, Wallace. *The American West as Living Space.* Ann Arbor: University of Michigan Press, 1987.

Williams, Terry Tempest. *Refuge: An Unnatural History of Family and Place.* New York: Vintage Books, 1991.

Worster, Donald. *Rivers of Empire: Water, Aridity, and the Growth of the American West.* New York: Pantheon Books, 1985.

Related publications that include work by members of the Water in the West Project:

Dawson, Robert. *Robert Dawson Photographs.* Introduction by Ellen Manchester. Tokyo: Gallery Min, 1983.

Dawson, Robert, and Gray Brechin. *Farewell, Promised Land: Waking from the California Dream.* Berkeley: University of California Press, 1999.

Dawson, Robert, et al. *Ansel Adams New Light: Essays on His Legacy and Legend.* Untitled #55. San Francisco: Friends of Photography, 1993.

Finkhouse, Joseph, and Mark Crawford, eds. *A River Too Far: The Past and Future of the Arid West.* Photographs by the Water in the West Project, Reno, Nevada: Nevada Humanities Committee and the University of Nevada Press, 1991.

Foresta, Merry. *Between Home and Heaven: Contemporary American Landscape Photography.* Washington, D.C.: National Museum of American Art, Smithsonian Institution in association with the University of New Mexico Press, 1992.

Goin, Peter. *Humanature.* Austin: University of Texas Press, 1996.

——. *Nuclear Landscapes.* Baltimore: Johns Hopkins University Press, 1991.

——. *Stopping Time: A Rephotographic Survey of Lake Tahoe.* Albuquerque: University of New Mexico Press, 1992.

——. *Tracing the Line: A Photographic Survey of the Mexican-American Border.* Reno: Black Rock Press, 1987.

Goin, Peter, ed., and Ellen Manchester. *Arid Waters: Photographs from the Water in the West Project.* Reno: University of Nevada Press, 1992.

Goin, Peter, Robert Dawson, and Jill Winter. "Dividing Desert Waters." *Nevada Public Affairs* 1 (1992).

Hagen, Charles, ed. "Beyond Wilderness." *Aperture* 128 (1990).

Johnson, Stephen, Gerald Haslam, and Robert Dawson. *The Great Central Valley: California's Heartland.* Berkeley: University of California Press, 1993.

Klett, Mark, Ellen Manchester, and JoAnn Verburg. *Second View: The Rephotographic Survey Project.* Albuquerque: University of New Mexico Press, 1984.

Phillips, Sandra S. *Crossing the Frontier: Photographs of the Developing West, 1849 to the Present.* San Francisco: San Francisco Museum of Modern Art and Chronicle Books, 1996.

Riebsame, William E., et al. *Atlas of the New West: Portraits of a Changing Region.* New York: W. W. Norton, 1997.

Virga, Vincent, and Curators of the Library of Congress. *Eyes of the Nation: A Visual History of the United States.* New York: Alfred A. Knopf, 1997.

Acknowledgments

We gratefully acknowledge the many individuals and institutions who assisted us in our effort to understand and synthesize the complex issues surrounding the founding of the Newlands Reclamation Project and its impact on the Truckee River and Pyramid Lake watersheds. It is also important to note that Verna Curtis, Curator of Photography, Prints and Photographs Division of the Library of Congress, has created an archive collection of photographs from Robert Dawson and Peter Goin on the Truckee River/Pyramid Lake Project. Jill Winter, publications editor of the *Nevada Public Affairs Review* at the University of Nevada, Reno, provided an opportunity for Peter and Robert to co-edit an issue titled "Dividing Desert Waters" (1992, no. 1).

Chad Blanchard and Jeff Boyer, U.S. District Court Water Master's Office, introduced a water management perspective. Graham Chisholm provided a greater understanding of the environmental and conservation issues and readily reviewed our captions and manuscripts for factual accuracy. Joe Ely and Mervin Wright Jr., both of whom have served as tribal chairmen, informed the authors about the Paiute perspective. Louise Evans, George Frey, Hammie and Bruce Kent, and Michon Mackedon helped us with the ranchers' perspective. Martha Knack's ethnology of Pyramid Lake provided invaluable assistance. Lighthawk and its pilots assisted in providing an aerial perspective. Kent and Marcia Minichiello were important supporters of the project and curated an early exhibit of Peter's and Robert's photographs at the Washington Center for Photography in Washington, D.C. Paul Starrs supervised the cartography and provided invaluable assistance in reviewing ideas. Mary gratefully acknowledges the Nevada Humanities Committee for the research grant that supported in part the writing of the text.

We remain grateful to these additional people and organizations for helping with this project: Ron Anglin; Christina Barnet; Robert E. Blesse; Charlotte Borgeson; Janet Carson; Stephen Davis; Katie Frazier; Dana and Kari Goin; Lynne Hartung; Robert Henderson; C. Anne Janik; Martha Knack; Elwood Lowery; The Nature Conservancy; Naval Strike and Air Warfare Center at Fallon, Nevada; Nevada Historical Society; Mary Reid; Ann Ronald; Special Collections Division of the Getchell Library, University of Nevada, Reno; Mary Stewart; Garry Stone; Rose Strickland; Stephen Tchudi; Kathryn Totten; U.S. Fish and Wildlife Service; John Warner; Wild Island, Sparks; and Vera Williams.

About the Authors

ROBERT DAWSON is an instructor of photography at San Jose State University and at Stanford University. His books include *Robert Dawson Photographs*, *The Great Central Valley: California's Heartland* (co-authored with Stephen Johnson and Gerald Haslam), and *Farewell, Promised Land* (co-authored with Gray Brechin). He is founder and co-director with his wife, Ellen Manchester, of the Water in the West Project. Mr. Dawson has received a National Endowment for the Arts Fellowship and shared with Gray Brechin the Dorothea Lange–Paul Taylor Prize from the Center for Documentary Studies at Duke University. Mr. Dawson's photographs have been collected by the Museum of Modern Art in New York, the National Museum of American Art (Smithsonian Institution), and the Library of Congress. He lives with his family in San Francisco, California.

PETER GOIN is a Foundation Professor of Art in photography and video at the University of Nevada, Reno. He is the author of four books, including *Tracing the Line: A Photographic Survey of the Mexican-American Border* (limited-edition artist book, 1987); *Nuclear Landscapes*; *Stopping Time: A Re-photographic Survey of Lake Tahoe*, with essays by C. Elizabeth Raymond and Robert E. Blesse; and *Humanature*. He served as editor of a fifth book, *Arid Waters: Photographs from the Water in the West Project*. His most recent book, *Atlas of the New West*, was a collaborative effort with members of the Center of the American West at the University of Colorado at Boulder. His photographs have been exhibited in more than fifty museums nationally and internationally and have been collected by major museums and repositories. He is the recipient of two National Endowment for the Arts Fellowships. He lives with his family in Reno, Nevada.

MARY WEBB teaches writing and literature at the University of Nevada, Reno. Since joining the faculty there in 1985, she has developed new courses in technical writing and literature of the desert. Her scholarly interests include writing about the natural world, writing across the curriculum, and technical writing. She was awarded a research grant from the Nevada Humanities Committee to support in part the writing of *A Doubtful River*. She lives in Reno, Nevada.